YORKSHIRE WINDMILLS

THROUGH TIME
Alan Whitworth

AMBERLEY PUBLISHING

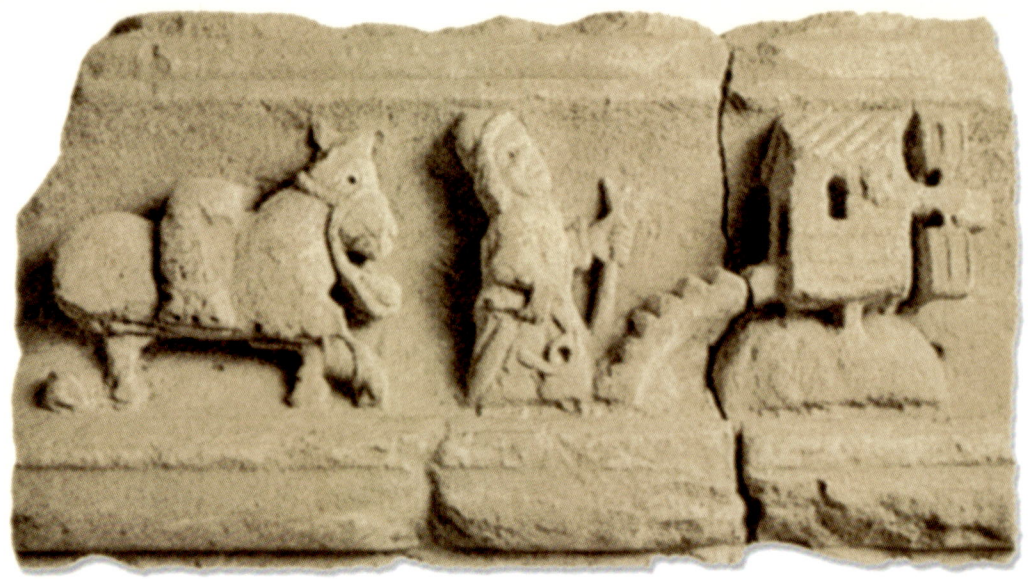

An early, if not the earliest, representation of a Yorkshire post windmill, seen in this carving at Rievaulx Abbey showing someone bringing a sack of corn to be ground, carried on the back of a horse.

First published 2011

Amberley Publishing
The Hill, Stroud,
Gloucestershire, GL5 4EP

www.amberley-books.com

Copyright © Alan Whitworth, 2011

The right of Alan Whitworth to be identified as the Author of this work has been asserted in accordance with the Copyrights, Designs and Patents Act 1988.

ISBN 978 1 4456 0605 7

All rights reserved. No part of this book may be reprinted or reproduced or utilised in any form or by any electronic, mechanical or other means, now known or hereafter invented, including photocopying and recording, or in any information storage or retrieval system, without the permission in writing from the Publishers.

British Library Cataloguing in Publication Data.
A catalogue record for this book is available from the British Library.

Typeset in 9.5pt on 12pt Celeste.
Typesetting by Amberley Publishing.
Printed in the UK.

Introduction

Few structures add as much atmosphere to the English countryside as a windmill. Even in ruination, a mill possesses a dignity few other buildings can equal. The history of windmills stretches back far into antiquity, and while none of the first mills in the country survive, among the windmills which do remain to the present time are some that are at least three hundred years old, and many over a century in age.

Yorkshire today is perhaps not so well noted for windmills as other counties. Certainly in comparison with Norfolk, Suffolk and Lincolnshire, the county pales into insignificance; but in times past, stretching across the three Ridings, Yorkshire could hold its own for numbers. As we travel about it now, it is difficult to imagine a landscape populated every few miles with windmills, but so it was. Indeed, one authority writing in the September 1954 issue of the *Yorkshire Life* suggested that approximately one windmill still existed 'every six miles over a wide area of the East Riding'.

It is said that windmills were introduced in Britain by returning crusaders. Possibly this is true, as the earliest written reference to a windmill in England, dated 1185, relates to a mill at Weedley, in Yorkshire, let at a rental of eight shillings a year in the ownership of the Knights Templar, a military order founded to guard pilgrims crossing the Holy Land.

Originally windmills would have been built on the open fields or common land of the village. Nevertheless, the erection of a mill was a privilege granted only to the lord of the manor or the Church, and with its ownership went certain rights in respect of milling corn, known as Mill Soke. Under this feudal custom, tenants of the manor were required to bring their corn to the manorial mill for grinding. The miller, often a tenant put in by the overlord, was allowed for his labour to retain a predetermined percentage of the flour he produced, with the exception of that belonging to his lordship.

The earliest medieval windmills were so designed that they became known as post mills. Free-standing, the wooden-framed body of the mill was supported on a massive upright post which stood on a horizontal frame of two timbers crossed and jointed at right-angles. This arrangement of construction allowed the body of the mill to be rotated on the post in order to be faced into or away from the wind. Post mills were popular for many centuries, and if the site proved unsatisfactory it was not uncommon for early windmills to be moved bodily to new locations to better catch the wind. One such was that relocated by order of Abbot William Meaux from Beeforth to Skipsea during the years 1372–96.

The construction of windmills reached a peak in the mid-nineteenth century, and by 1879 their prominence had begun to wane. An East Riding directory for that year lists some 113 working windmills (excluding the city of Hull). This number dropped to 104 by 1892; in 1897, the year of Queen Victoria's Diamond Jubilee, it had tumbled dramatically to 57 and fallen to 33 by 1909. In the year 1921 the figure for operational East Riding windmills had plummeted to just eighteen! During this time, many millers had installed steam engines, or had their windmills converted to electric power, two facts that more than any other hastened the demise of the windmill. In the East Riding, the last two mills to operate by wind were Preston's Mill, at Seaton Ross, dismantled in 1951, and Skidby Mill, where the use of wind-power was discontinued in 1954.

Lastly, I should like to record my debt of gratitude to Professor Donald W. Muggeridge and his father, without whose foresight in photographing windmills of Yorkshire at a period when great changes were occurring our archives would be the poorer, and who by correspondence has given permission for their use. These photographs are housed in the Templeman Library, University of Kent, Canterbury, to whom Mr Muggeridge made a donation of the glass negatives of his father and his own collection. These form the basis of this book unless otherwise stated; all the modern colour photographs are mine.

Acknowledgements

Obviously, with the production of any book, the research could not have been carried on without the assistance of others. As a consequence, I am indebted to the many owners who allowed me the opportunity to measure and photograph their mills and talk to me about their buildings. However, I am particularly indebted to the following individuals who have assisted me with notes, especially Michael G. Fife, Honorary Secretary of the Poppleton History Society, and Mrs Barbara Howard, whose family descendants, the Nicholsons, include five generations of corn millers and who was happy to share her family history with me. I am also indebted to the many who have written before on the subject; in particular I should like to acknowledge the work of Roy Gregory and his volume *East Yorkshire Windmills* (1985). Finally, thanks to the staff of various libraries and institutions for finding references and allowing the use of material, in particular the late Tony Munford, Archives and Local Studies Section, Rotherham Central Library and Christopher Ketchell, Local History Unit, Hull College.

Aberford North and Hicklam

Aberford North Mill (WY), photographed 23 August 1934. Aberford possessed two corn windmills, both dating from the eighteenth century. This one, right, situated near to the village, was named Aberford North Mill and stood up Windmill Lane, which, like the mill itself was swept away in 1984 by the construction of the A1(M) bypass road. This may have been the mill insured in 1782 for the sum of £800. The mill was once surrounded by an earthen mound which gave access to the mill at first floor level. A change in the brickwork shows that it has been heightened at some date. The second windmill, Hicklam Mill, is visible from the A1(M) below and may be connected with nearby Hicklam House. It is built of Magnesian limestone. In 1822 the miller of Hicklam Mill was Joseph Steel. Today, this windmill has been converted to residential use.

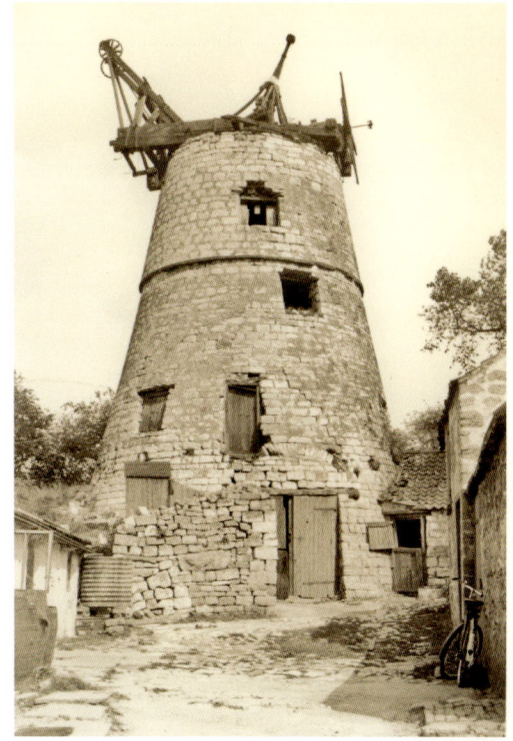

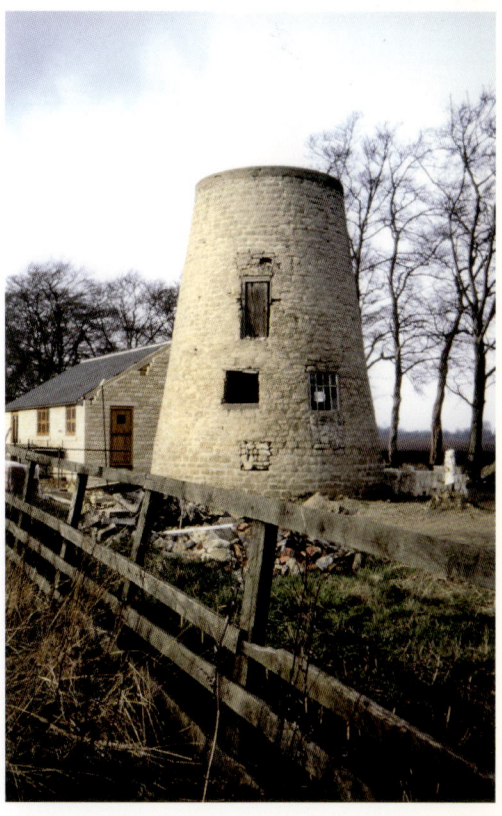

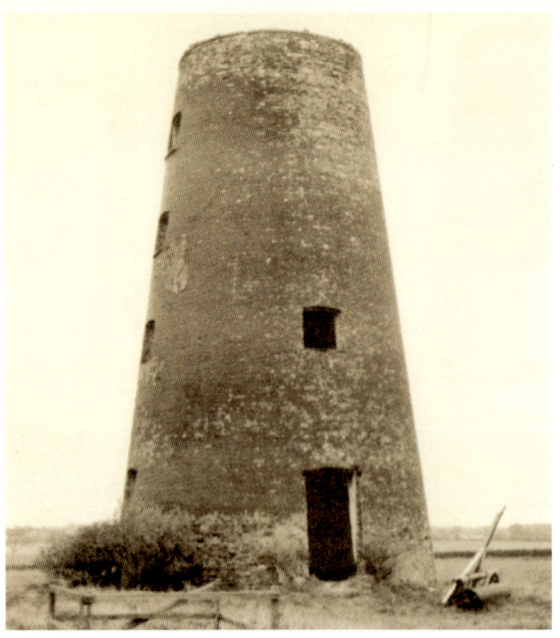

Appleton Roebuck

On Jeffery's *Map of Yorkshire*, published in 1772, a windmill is shown here at Appleton Roebuck (NY). Today, a ruined mill stands a little to the west of the village. The derelict mill, built of machined brick and once tarred, stands four storeys high and only dates from the nineteenth century and therefore replaced, or was an additional mill to, the 1772 windmill. Karl Wood the windmill artist painted a mill here in August 1934, showing it as an empty shell. Internally, the mill measures 22 feet in diameter and has walls 19 inches thick. Some supporting beams exist in the upper levels and a base plate of cast iron bolted to a squared stone still remains more or less *in situ*. In 1822 the corn miller was Robert Denton. It used to possess three pairs of millstones, a wire dresser and gearing for an external engine. It is said work ceased here by 1885. Today, there is a planning application to turn it into an astronomical observatory.

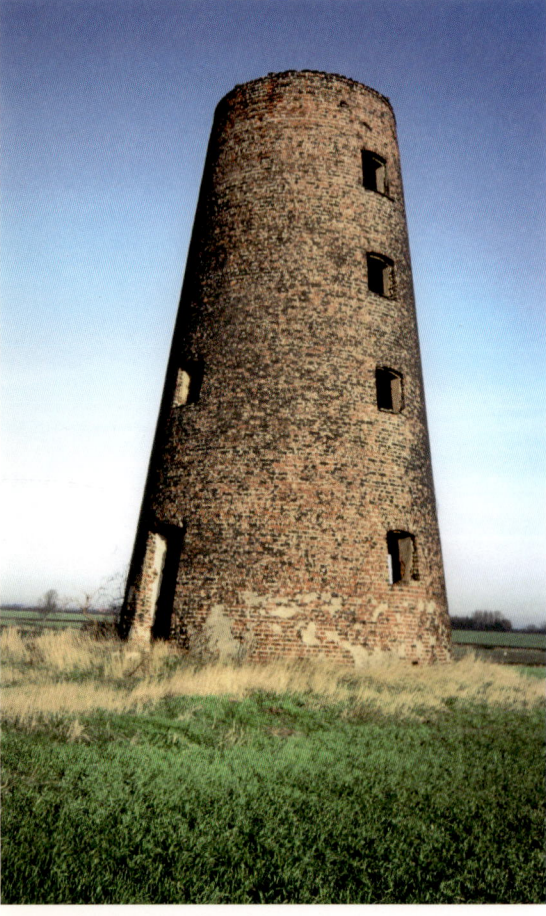

Windmill Inn

The mill and mill house at Askham Richard (NY) stood along Old Mill Lane, shown above, and both were lost during the construction of the village bypass in 1986–7. In 1822 the corn miller was John Gaterhill. In 1896 Elizabeth, widow of John Gilson, was both licensee of the Windmill Inn and miller at the mill. She fell into debt about 1896 and the mill most likely ceased to work about this date. Below, the Windmill Inn when it was a private residence.

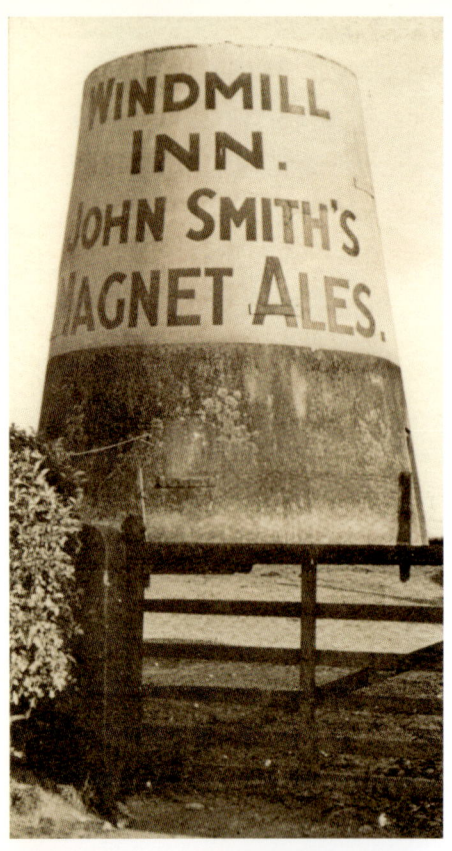

Askham Richard

Askham Richard windmill, left, made a convenient advertisement sign. Nearby, a windmill is shown on a site at Askham Bryan (NY) on John Ogilby's map, dated 1675, and on Jeffery's map of 1772. The mill remains, which only date from the late eighteenth century and possibly replace an earlier wooden post mill, are situated on the same ridge as a number of other windmills. As with other mills of this period, the tower is very squat and has a pronounced batter. Exposed on a circular mound and constructed of ashlar masonry, a pressure-fed water tank was added to the top of the disused windmill shell at the end of the nineteenth century. The cement-rendered tank carries a fenestrated parapet and is out of alignment with the mill tower. From an aesthetic point of view, the piping connected with its use as a water tank is distracting, and one cannot but compare it with the windmill tower at Bramham, where all the piping is hidden away, which allows the tower to retain its essential profile.

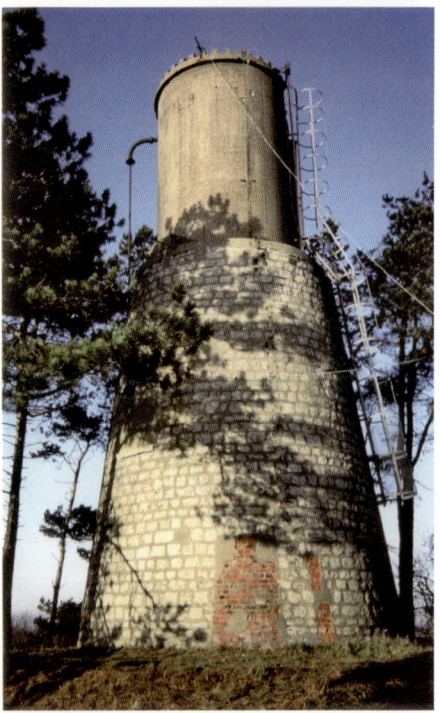

Bainton

Bainton (EY) had a windmill in 1279, which was recorded up to the sixteenth century. In 1818 Bainton obtained a new windmill. Inside the brick shell stump the collapsed woodwork has some carpenter's marks, suggesting that it could be reused wood from a previous mill. At the time Bainton Mill was newly erected it had four patent sails, and an ogee-shaped cap with a fantail mechanism and three pairs of mill-stones, two French and a grey. This was the most common arrangement for a village tower mill. Mr R. Wilson, an engineer and millwright at Driffield from 1898 until 1911, recalls an incident concerning Bainton. "When I was about fifteen years old I was painting the main sails. My master always taught us to chock the brake wheel but on this occasion I didn't. I had just got on to the sail when a great gust of wind started them moving. I had to drop fifteen to twenty feet to the ground and watch my paint go round with the wands!"

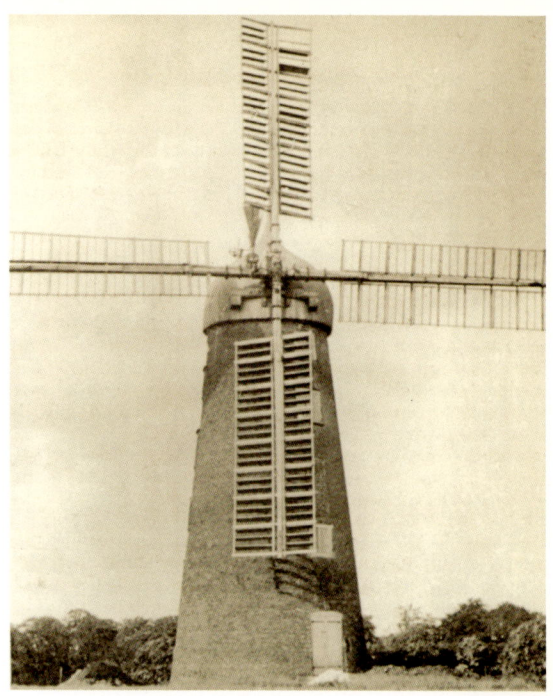

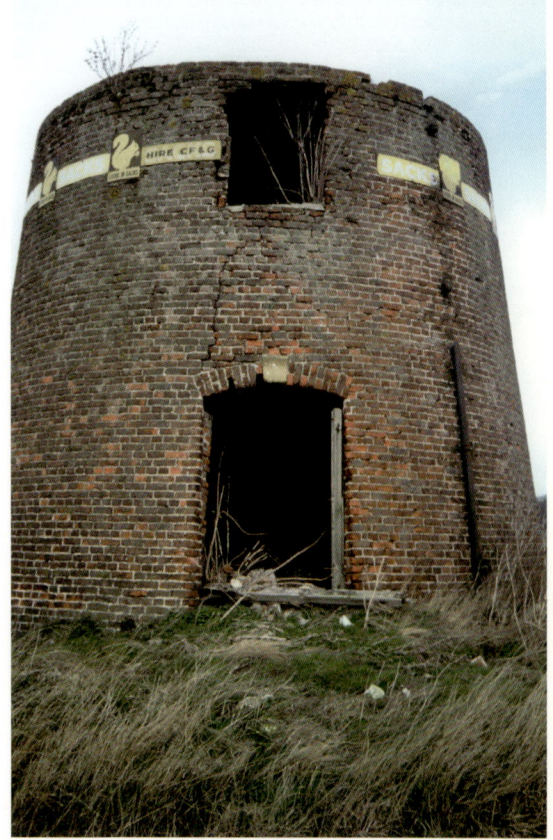

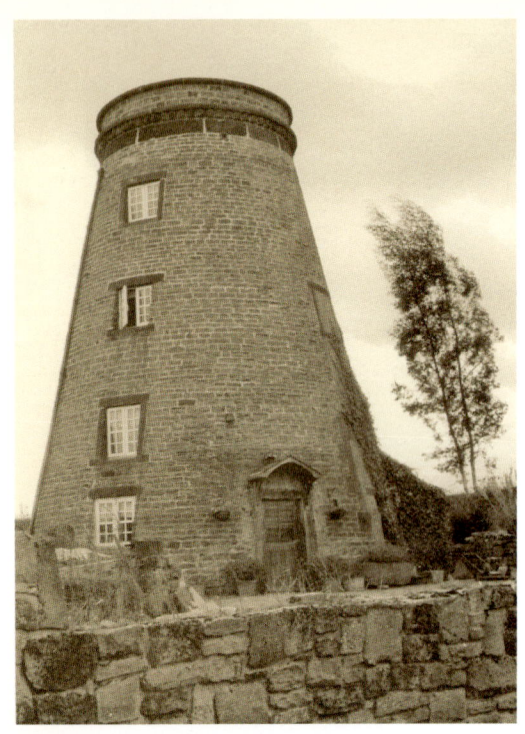

Barrow

The mill at Barrow, near Wentworth (WY), was constructed from materials provided by taking down a windmill in nearby Wentworth village. The erection of Barrow Mill was completed by 1793, and cost £382 9s 1¼d. A substantial house was built for the miller and his family, recorded in the Accounts for 1794. The mill ceased working around 1834 and Earl Fitzwilliam paid £135 1s 0d for 'Joshua Jackson's mill to be converted into two cottages'.

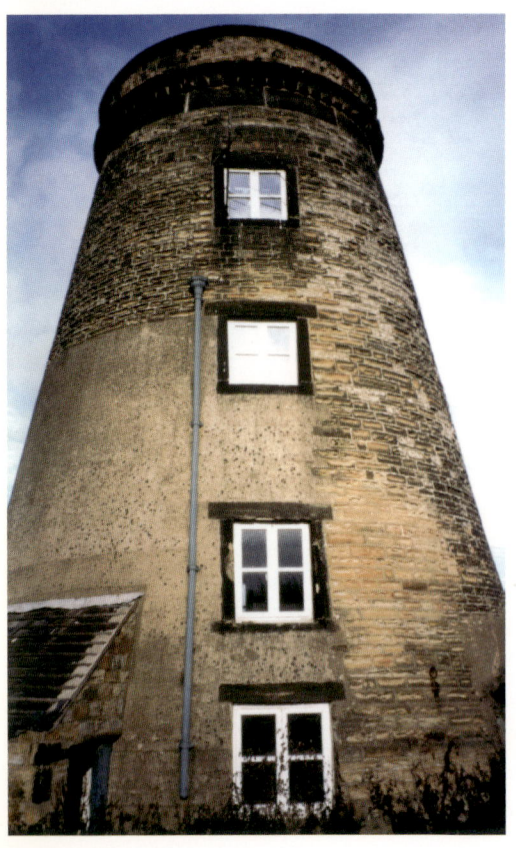
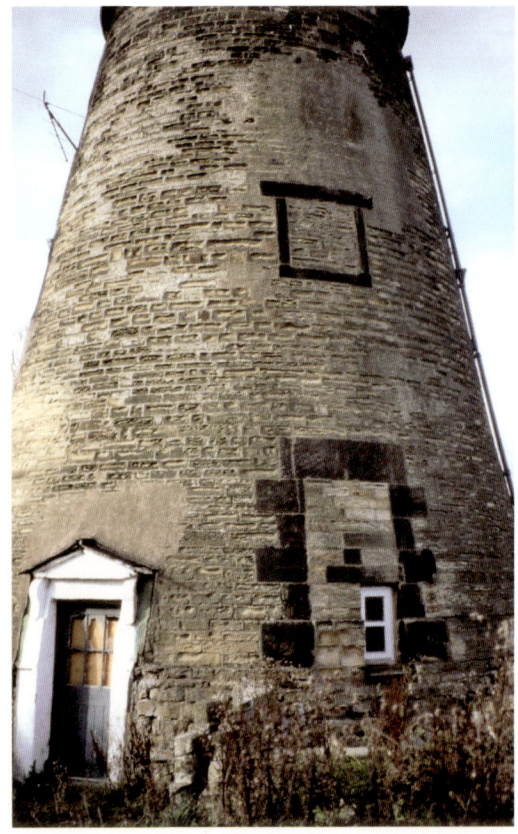

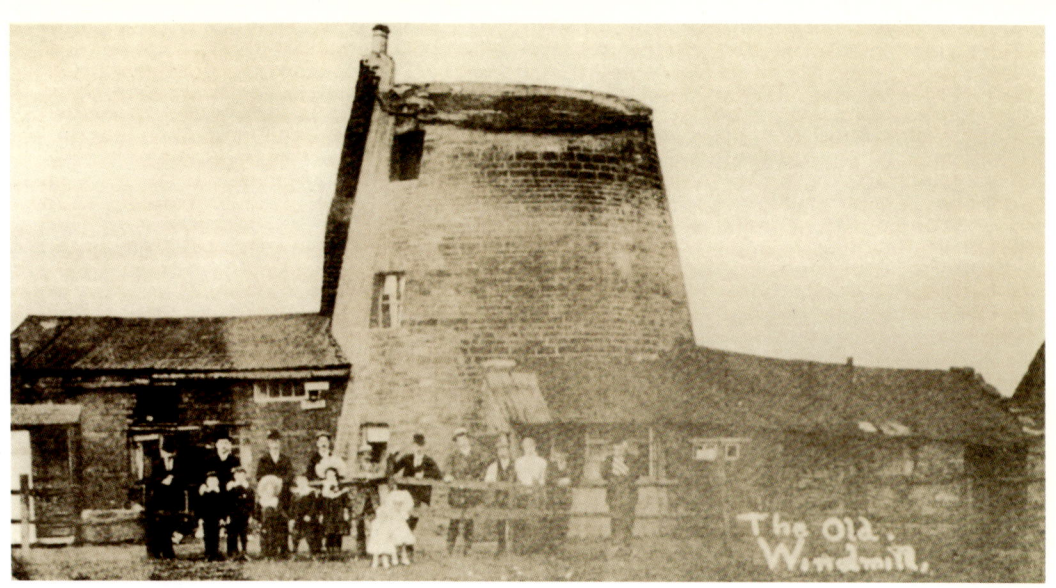

Bridlington

At least six windmills and three water mills stood in Bridlington during the nineteenth century, including, above, Duke's Mill, erected before 1823. A small tower mill whose internal measurement at the base was only 18 feet 6 inches, it was powered by four roller sails and winded with a fantail. Below is Lowson's Mill, sometimes known as Spring Mill, in a photograph dated *c.* 1890. This windmill stood on the west side of Springfield Avenue and was operated in conjunction with a nearby watermill.

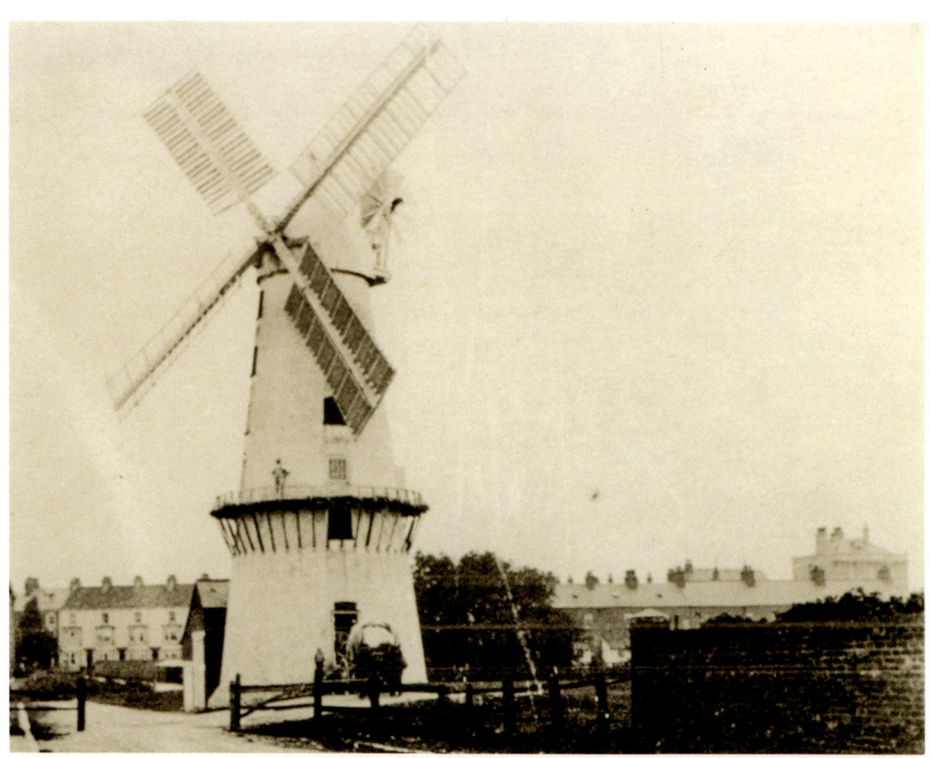

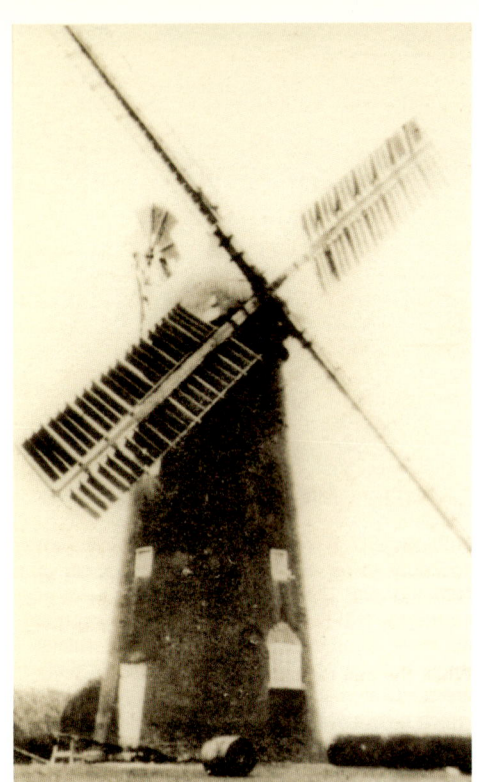

Beeford

A post windmill was first mentioned at Beeford (EY) in 1372, when the Abbot of Meaux ordered its removal to Skipsea in Holderness during the period 1372–96. 'A windmill with lands and the frank Pledge there' was recorded in 1588. There is no mention of a windmill on Jeffery's map of 1772. In 1820, a new mill of brick was erected; this probably replaced any earlier windmills, which would most likely have been wooden post mills. The nineteenth century mill had four patent sails, a fantail and two pairs of millstones. A third stone was added in 1880; also a barley mill, a screen for cleaning the wheat and a dressing machine to extract bran. The owner, George Whiting, died in 1820 and it was bought by James Booth, who went bankrupt ten years later; however, the mill survived but closed in 1933. Undoubtedly the early nineteenth-century structure is the mill which survives to this day as a ruined shell.

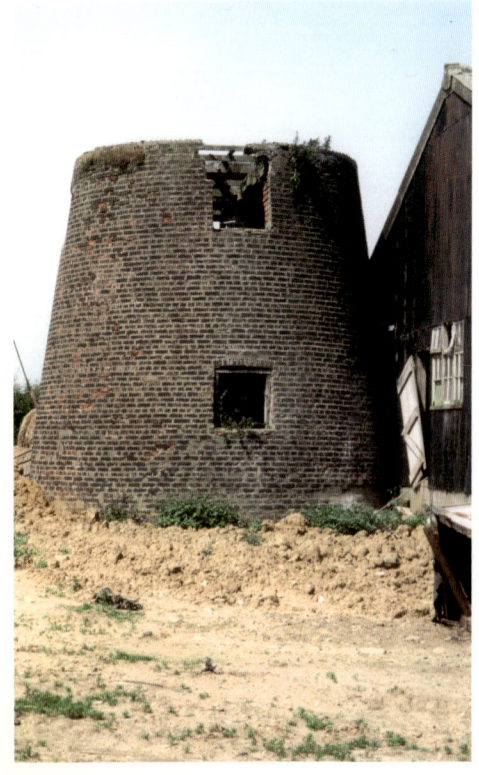

Bempton

Standing inside Bempton (EY) parish, this mill was called Buckton Mill and formed part of the Buckton family manor in 1314. Further confusion abounds as the miller, a woman, is also listed under Bempton. Even more confusing, at nearby Sewerby in 1619 a windmill stood in the fields 'nigh unto Bempton', probably on a site close to the boundary with Bempton which had been in the eighteenth century and later, was known as either Speeton or Bempton Mill.

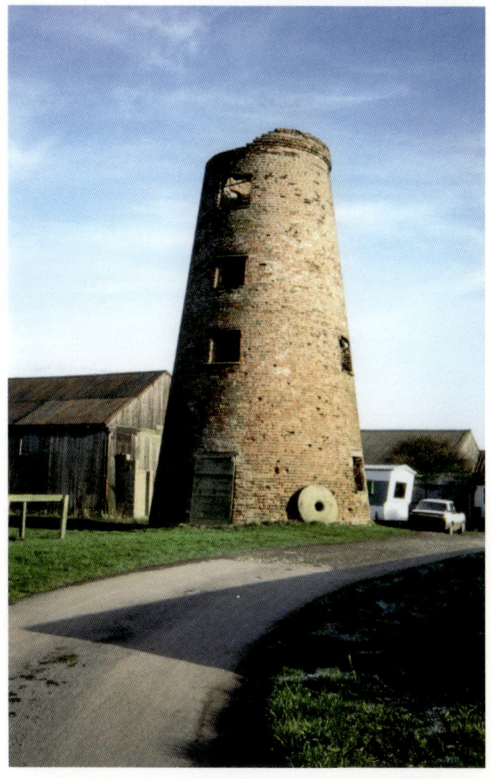

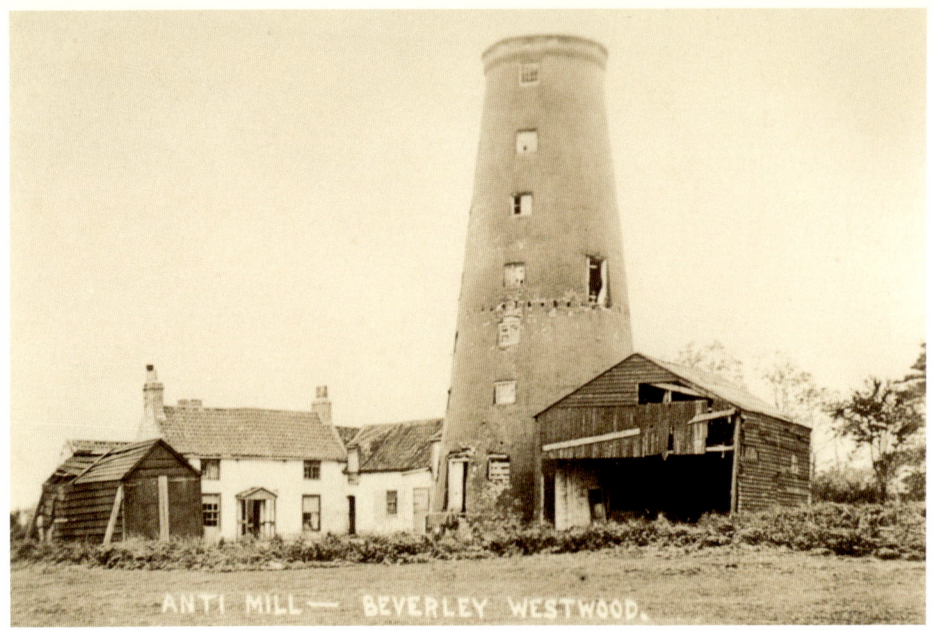

Black Mill

Black Mill, commonly known as Westwood Mill, was begun in 1801 and completed by August 1803. Taller than most mills in Beverley, it survives in the keeping of the borough council. Originally the exterior was whitewashed, but afterwards the brick-work was tarred, giving it the name 'Black Mill'. The mill was damaged by fire in the 1840s and repaired, only to be part dismantled in 1868 at the end of the lease; the machinery was removed and sold for £55.

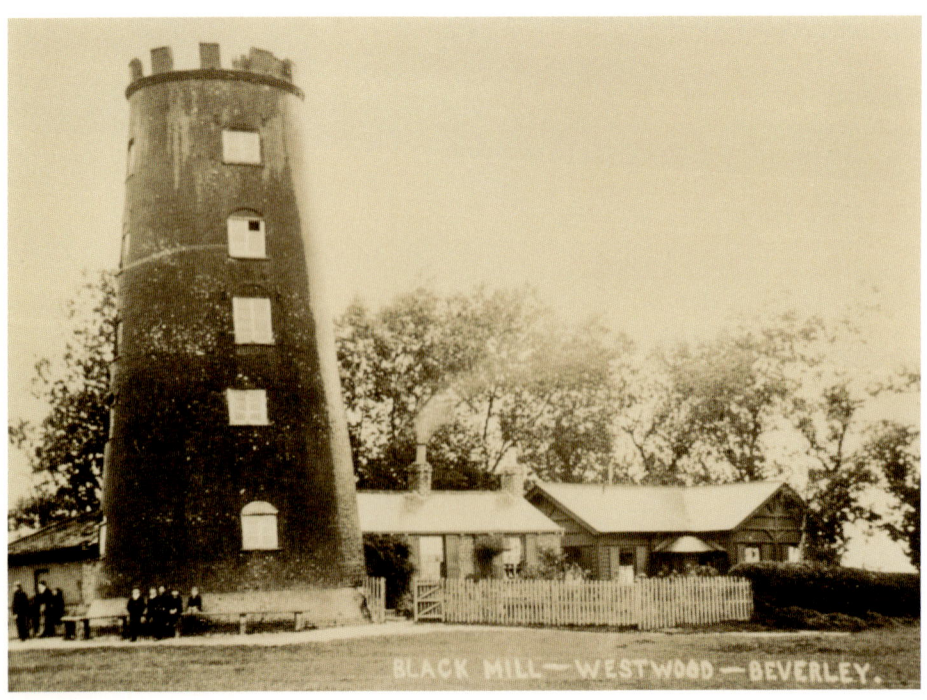

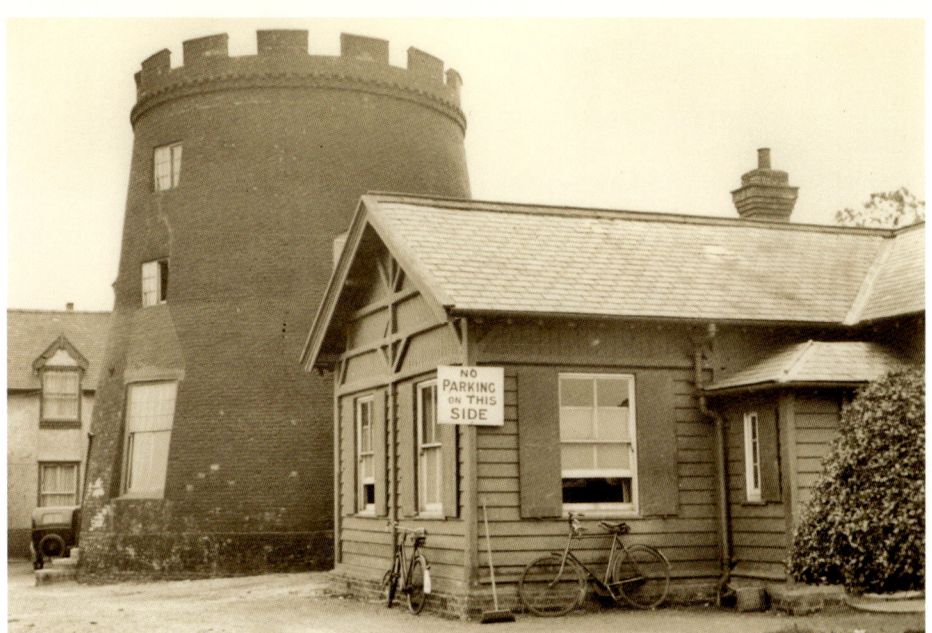

Beverley

The Beverley Union Mill Society, a co-operative organisation, was formed in 1799 and on 31 July 1800 John Tuke laid the foundation stone of this mill, which was leased to the society in 1804. It may have fallen out of use by 1863, following disagreements within the management committee. Soon afterwards it was worked by James Thirsk, who produced his famous 'Beverlac' flour here until the early 1890s. The mill tower was later incorporated into the Beverley Golf Club clubhouse, where it still remains.

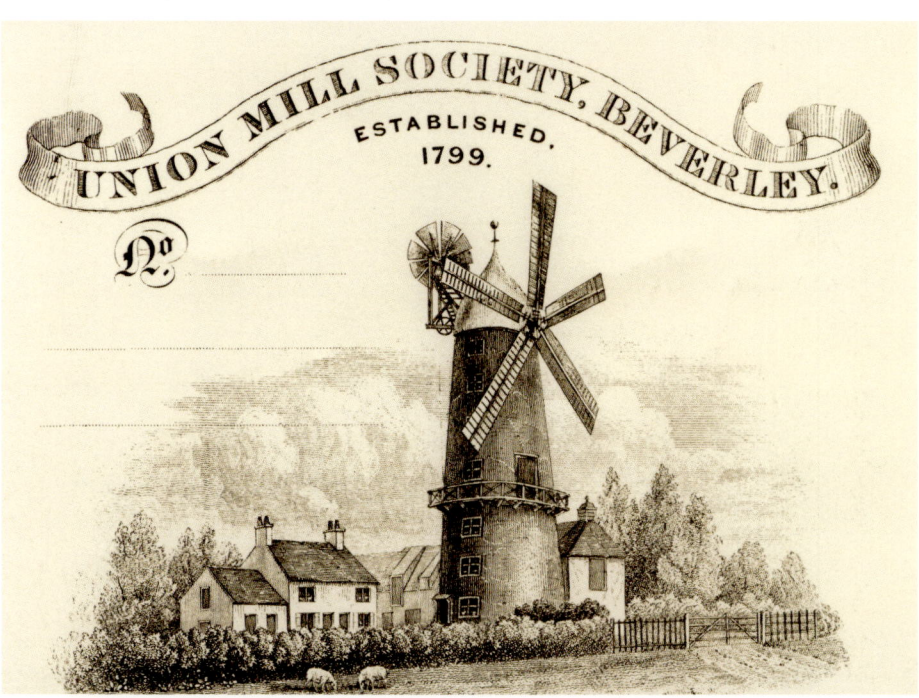

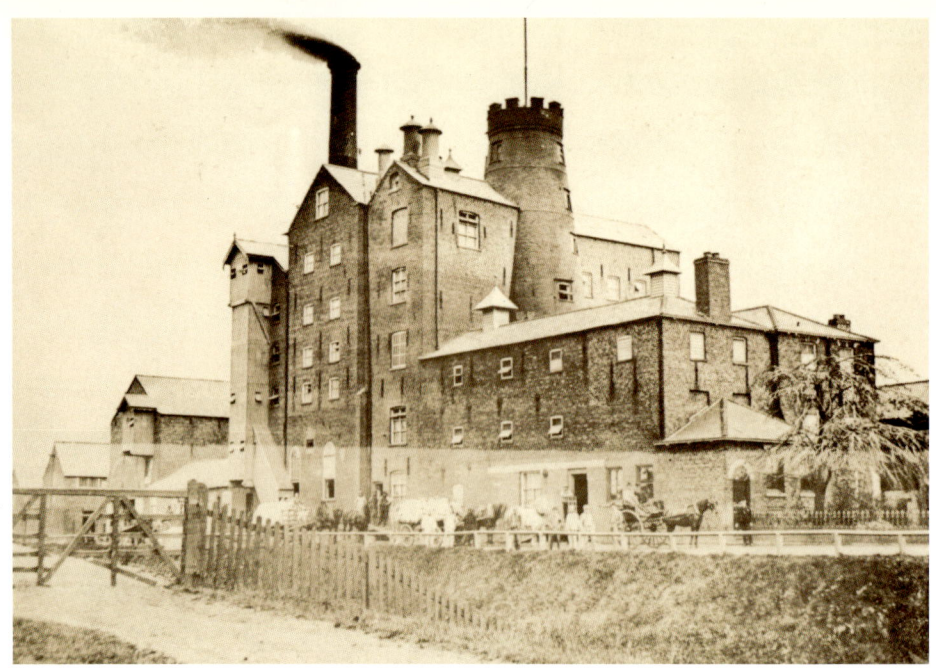

Fishwick's Mill

Josiah Crathorne's mill at Beverley (above) began life as a free-standing windmill; fire in 1858 razed the building to the ground. Rebuilt, it was fitted with a steam engine. It was damaged by fire in 1868 when the sails and fantail fell and wrecked the engine house. By 1900 it was almost entirely encased by ancillary buildings. Fishwick's Mill, below, was first mentioned in 1761 as Butt Close Mill, leased by John Maud. In 1800 William and John Fishwick took the lease. In 1861 the mill was dismantled and became the centre of rioting and the mill house was burnt down.

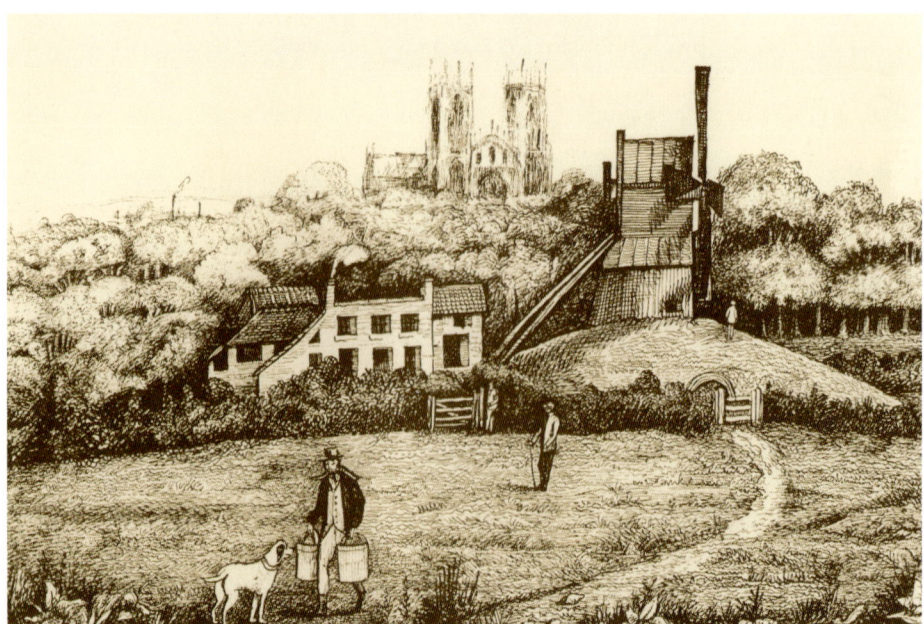

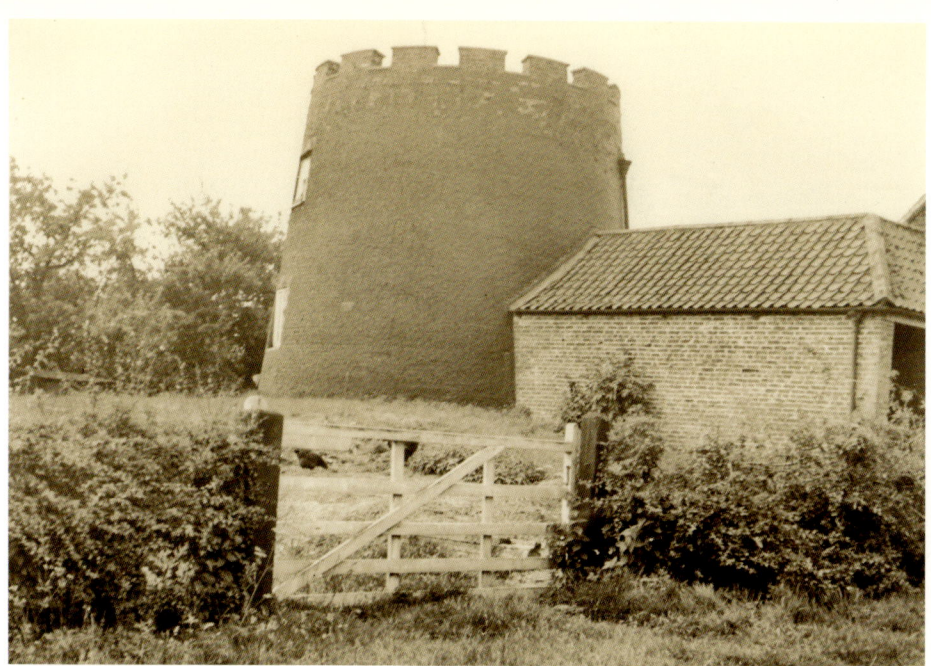

Bishop Burton

A windmill at Bishop Burton (EY) was first noted in the year 1250, one of the earliest recorded in the county. In 1754 two mills were mentioned here, one at the north end of the village, the other to the south; one miller was named Thomas Hopper. The North Mill was demolished by 1851. The southern mill survived, and after ceasing operation was converted into a dwelling.

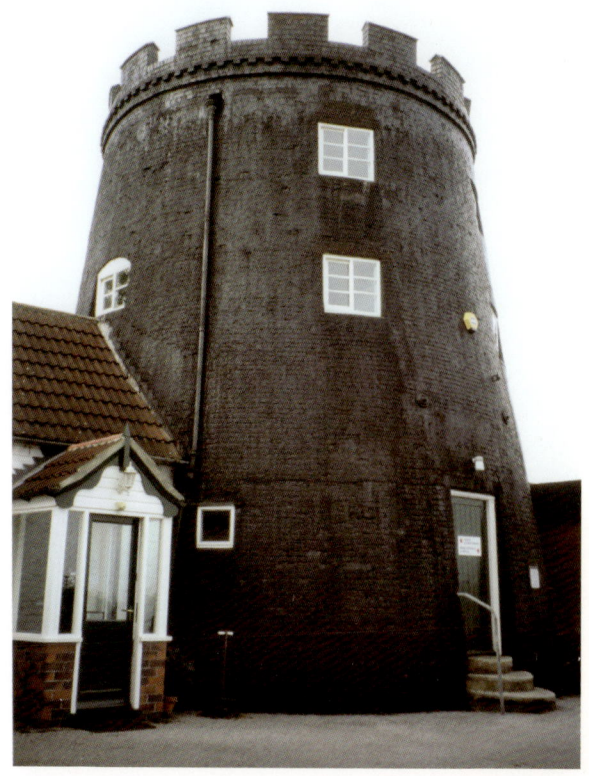

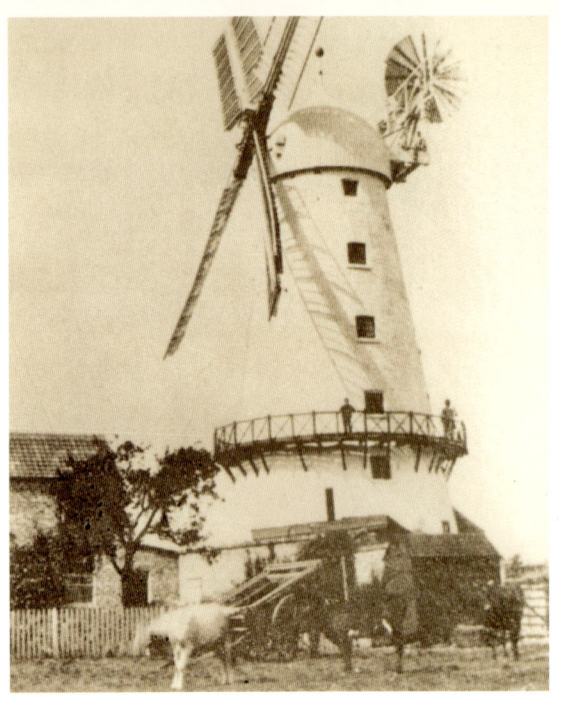

Boroughbridge

A stone-built tower windmill stands on the outskirts of Boroughbridge (NY), easily seen from the Great North Road, and dates from 1822. Often referred to as Skelton Mill, internally it has a diameter of 26 feet on the ground floor, tapering to 14 feet 9 inches on the sixth storey. In the year of its erection, Thomas Iles was the corn miller. The windmill was first powered with five sails but was later reduced to four and contained four sets of millstones and almost wholly cast iron shafts and gearing. The mill ceased operations in 1918. In 1962 work was begun to turn it into a residence that was only completed in 1996. In 1822 a public house in Boroughbridge was named 'The Windmill' and may have marked the site of another windmill in the town.

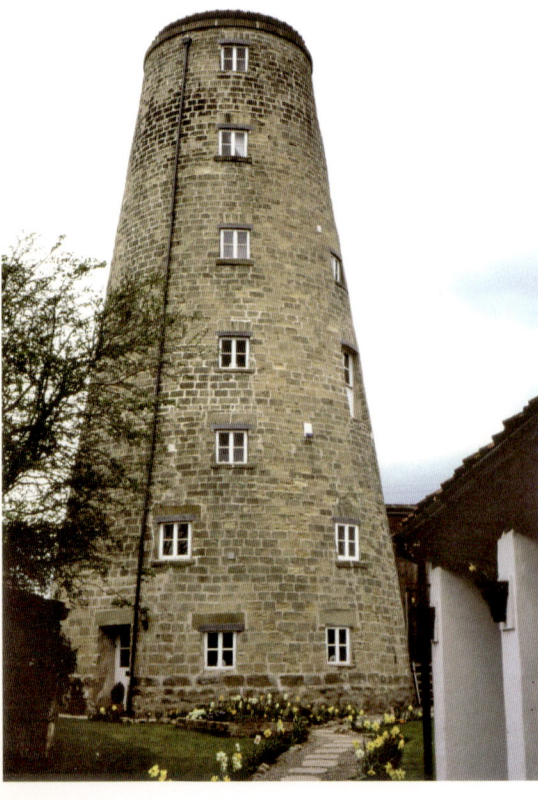

Bramham

Bramham (NY) windmill stands on the same ridge as Askham Richard and on a circular mound, a feature common to many in order to add height to an otherwise small structure. Curiously, however, at Bramham, on the south side, a stone arch beneath it leads to a blocked-up doorway. No explanation exists as to its purpose, but it is conceivable that it was an entrance from the mill to this space, which was most likely used as storage. Built toward the end of the seventeenth century in locally quarried Magnesian limestone, it was insured in 1794. It is said that the sails were lost during a storm in 1829. For a period of 200 years the Smith family were the millers. Interestingly, in 1822 three corn millers are named at Bramham: John Burnley, Michael Mande and Joseph Scott. However, whether three windmills existed at that time is unknown. Since 1927 the tower shell has been used as a water tank, first by Wetherby RDC and later by the Claro Water Board.

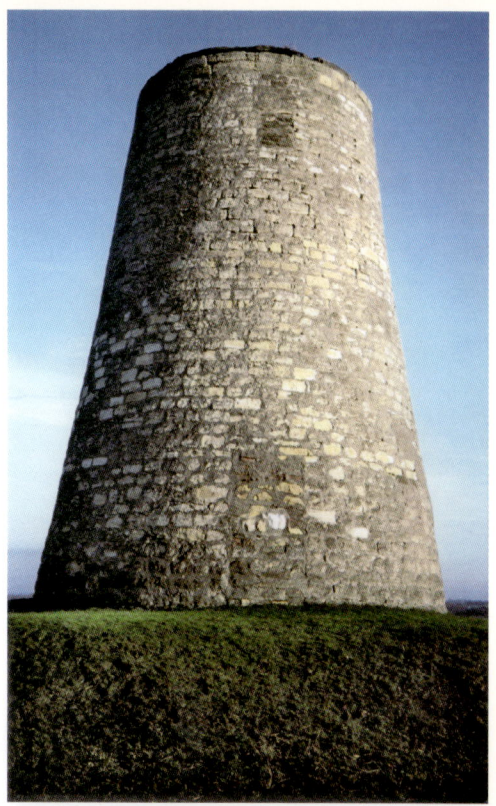

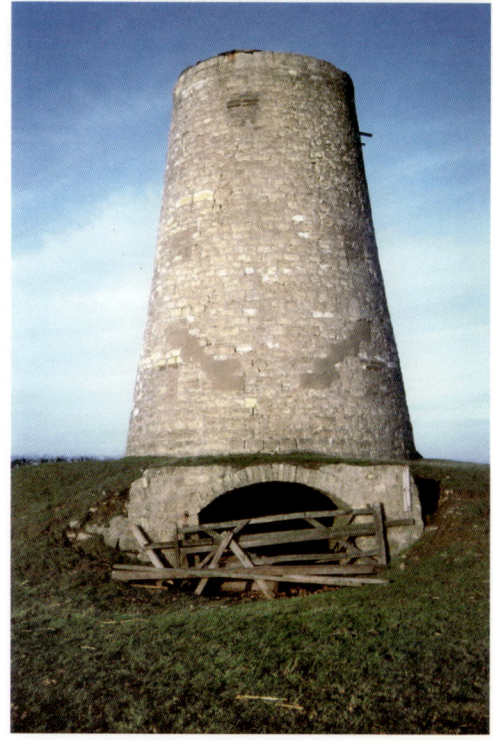

Brompton

Little is known about the windmill at Brompton near Northallerton, which stands off the main street and is not easily seen. The brick tower mill, small in stature, is now converted into a residence. There were few remains on site in 2004, but below, a stone with a cast iron plate was discovered and was no doubt the base plate for supporting the main drive shaft. An Ordnance Survey bench mark on the sill of the door of Brompton Mill was used during the First Primary Levelling, 1840–60, and was levelled with a height of 164 feet [50.1164 metres] above mean sea level (Liverpool datum). It was included on the Selby to Newcastle-upon-Tyne (branch line from Brompton to Northallerton, through Brompton Bank and Bulla Moor) levelling line. The surveyor's description was 'No.1 Mark on sill of door of Brompton Windmill; 4.29 ft. above surface' (p.385). This information tells us that at least the mill was in existence during the years given.

Burstwick

A windmill belonging to Burstwick Township, more properly known as Burstwick-cum-Skeckling (EY), was mentioned from the thirteenth to the sixteenth centuries, and may have stood near West Field in Skeckling. Another windmill at Skeckling was worked with a malting oven in 1772. Possibly it was this windmill that survived into the twentieth century. Built of brick and tarred to protect it from the weather, at first floor level holes can be seen, showing that an exterior gallery ran around the building, indicating that when this building was photographed on 21 August 1934, it had been reduced in height. Millstones came in three forms: the better-quality, known as French or burr stones, brought from France as ships' ballast, which were made up of small pieces fitted together like a jigsaw and held by an iron band; Peak or grey stones, referring to their origin, which was quarried from millstone grit in the Peak district of Derbyshire, or to their colour; and Cullin or blue stones, using volcanic lava, quarried near to and imported from Cologne.

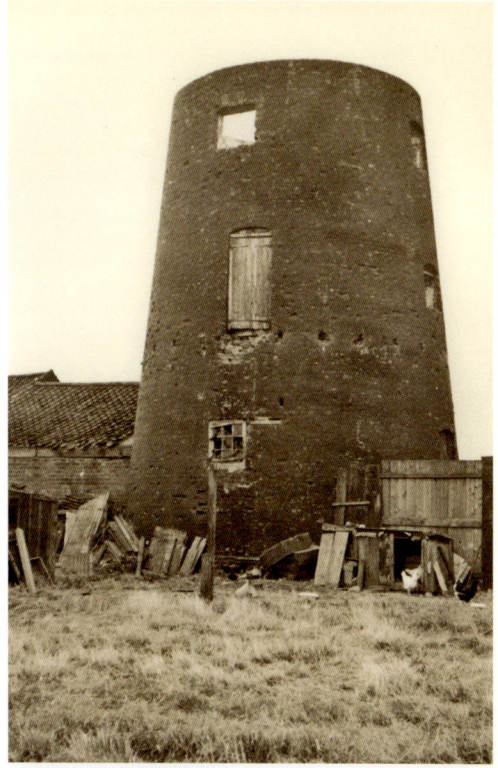

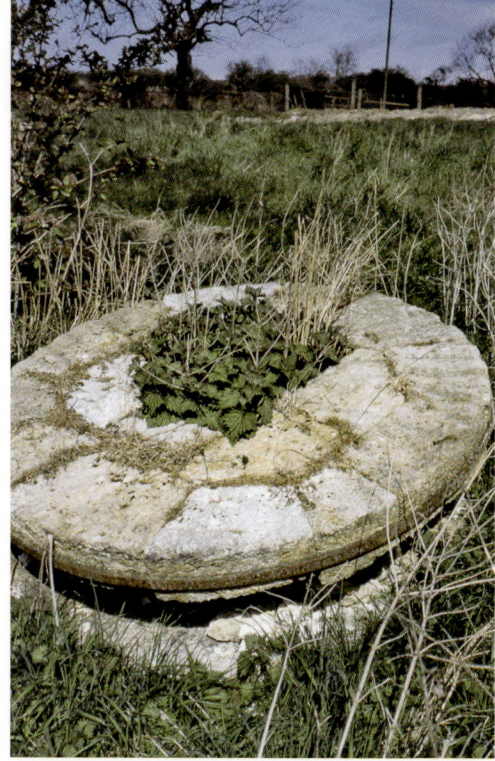

21

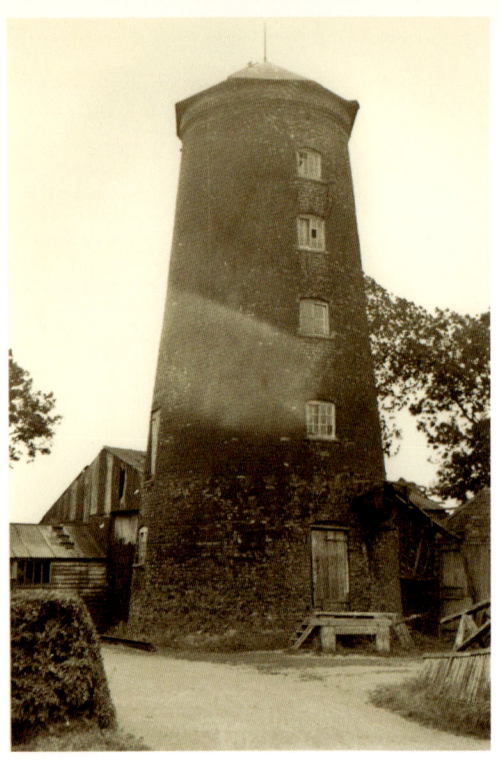

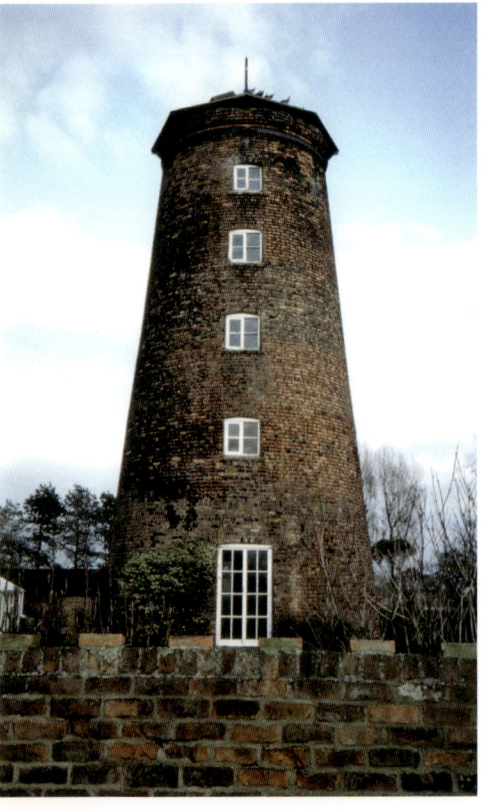

Burton Pidsea

A windmill was mentioned at Burton Pidsea (EY) as early as 1275, undoubtedly a post mill with cloth sails (known as 'wands' or 'sweeps') stretched over a wood frame. In order to control the speed of the sails in the varying wind conditions, the material had to be reefed in the manner of ship's sails – often a hazardous task in high or stormy winds, and there are recorded a number of fatalities. However, failure to reduce the speed of the sails could often result in damage to the grinding mechanism. It was built in 1824 by the Hull millwrights George & William Boyd. By 1872 the tenant miller was William Stephenson, who ran the mill until his death in the 1890s; the business was then carried on by his widow. In 1917 the freehold was purchased by Fred Stephenson, who remained in possession until his death in 1945. It seems likely he ceased milling in the late 1930s. Today, the remains have been converted to a dwelling.

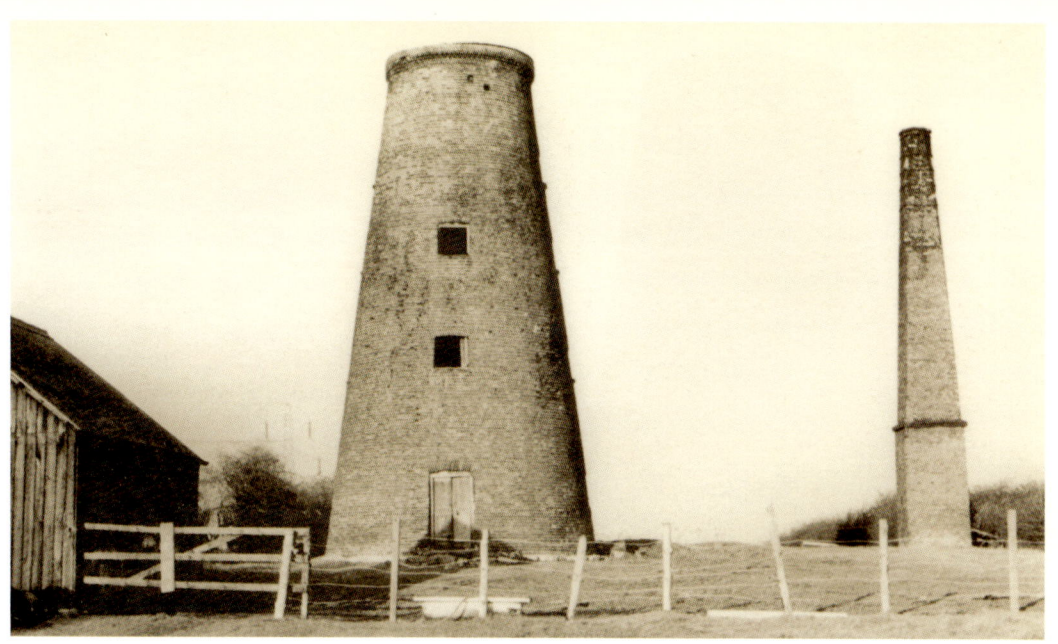

Cantley

The stump of Cantley (WY) mill and its adjacent chimney can be seen from the M18. Its age is uncertain, but it appears on Greenwood's map of Yorkshire, dated 1817, and also carries a datestone inscribed 'WC 1820'. As this has been inserted into an existing opening, it may commemorate some refurbishment or change of ownership. It is supposed that the initials 'WC', which can also be found on a barn in Chapel Lane, Branton, dated 1814, refer to William Carr, who certainly owned the mill and barn in 1849.

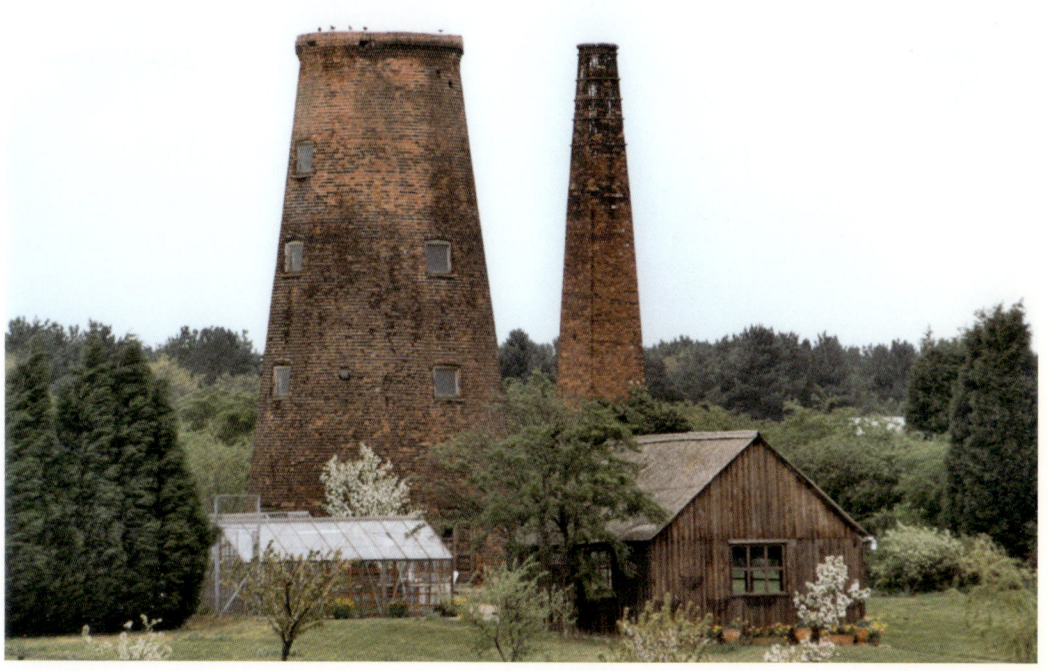

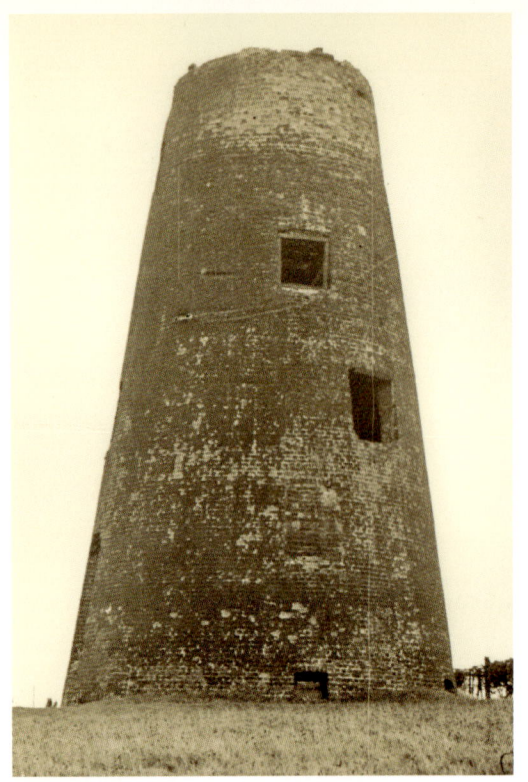

Carleton

At Carleton, near Pontefract (WY), the remains of a windmill were converted into a house by 1959. A photograph taken sometime after 1930, but before conversion, shows a derelict brick tower mill. The empty shell is complete to the curb and stands at least five storeys in height. Greatly patched with brick near the top, it appears to stand isolated in a rising open field and probably dates from the nineteenth century. Discarded machine around a site can include, below, the canister, which is a double socket on the end of the wind-shaft through which the stocks or beams of the sails pass. The wind-shaft carries the sails and the brake wheel that controls the speed of the sails.

Cherry Burton

The earliest record of a windmill at Cherry Burton (EY) is dated 1289. About the year 1295, the Prebendary of Dunnington owned a windmill here. This would no doubt have been a wooden post mill. There is no further mention of a windmill at Cherry Burton, and the brick shell that survives today in the centre of a farmyard on the outskirts of the village is probably of nineteenth-century origin. Karl Wood over-looked painting it, and at what date it ceased operating I do not know, but it was certainly derelict and without sails in 1935 when photographed on 27 June and similar views today show it practically unchanged in over sixty years.

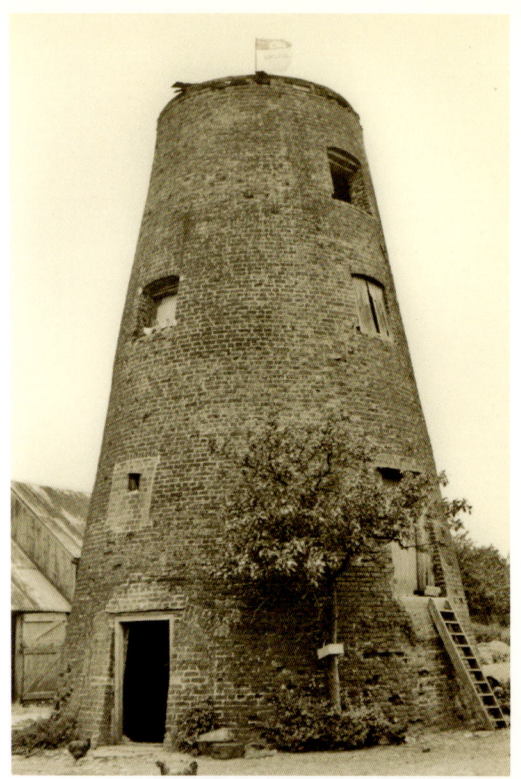

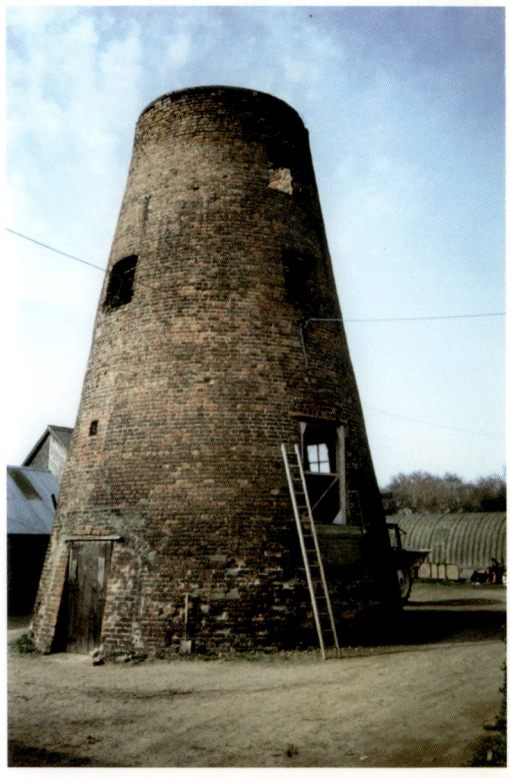

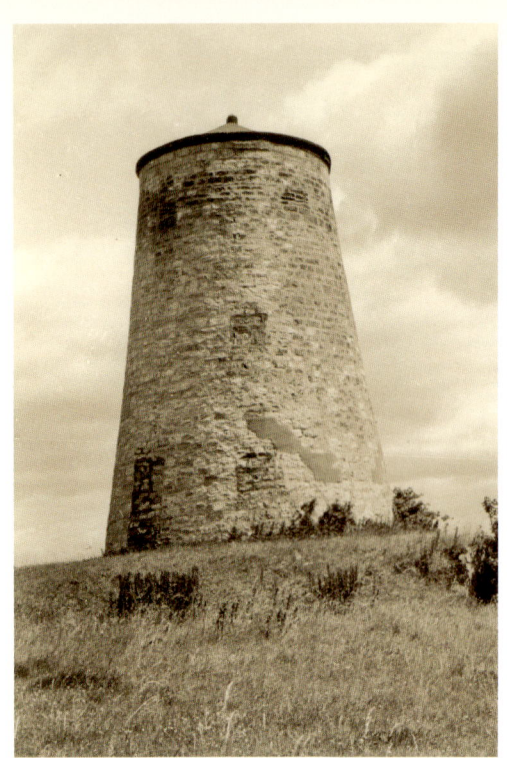

Clifford

The site and date of Clifford windmill near Tadcaster (WY) is now unclear, but it is probable from style, construction and materials that it dated from the eighteenth century, and survived to be photographed in July 1961. However, the illustration suggests a site on the village outskirts upon a rising eminence. In 1822 Michael Maud was corn miller. Below is Micklefield windmill, photographed in 2003.

Cottingham

The vagaries of using water power were well-understood. In summer watercourses could dry up to almost a trickle. In winter and spring they could flood with a flow of water almost too dangerous to use. At this time trees and other debris brought downstream by the river could prove a hazard also. As a consequence of this, numerous water-powered mills erected a windmill in order to have the best of both worlds. At Cottingham (EY) in the Hull Valley, the unreliable nature of the water supply to the long-standing watermill known as North or Snuff Mill made it impossible for the miller to meet the demand of the rising population of the village, so that his only option was to add wind power to his premises, which he did in 1813. This proved so successful that his example was followed at other watermills along the Hull Valley, namely Beverley Parks (1822), Foston-on-the-Wolds (1822) and Bryan Mills, Lockington (1840). This wind/watermill was demolished in 1900, but prior to that it had evidently lost two sails.

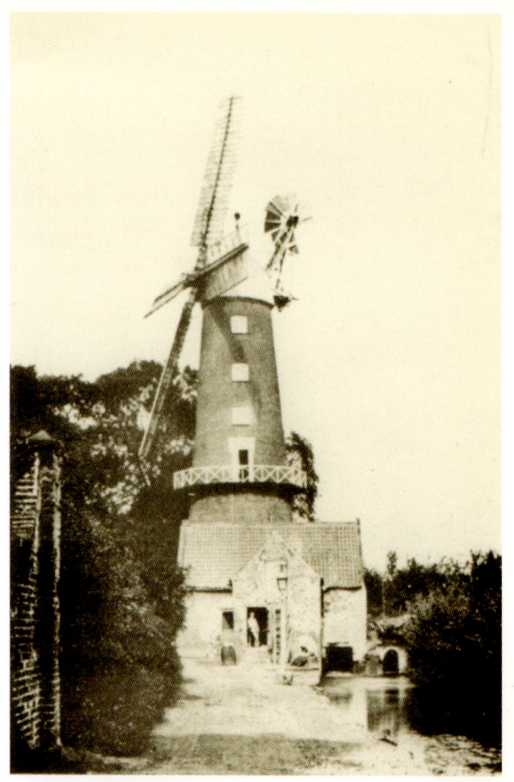

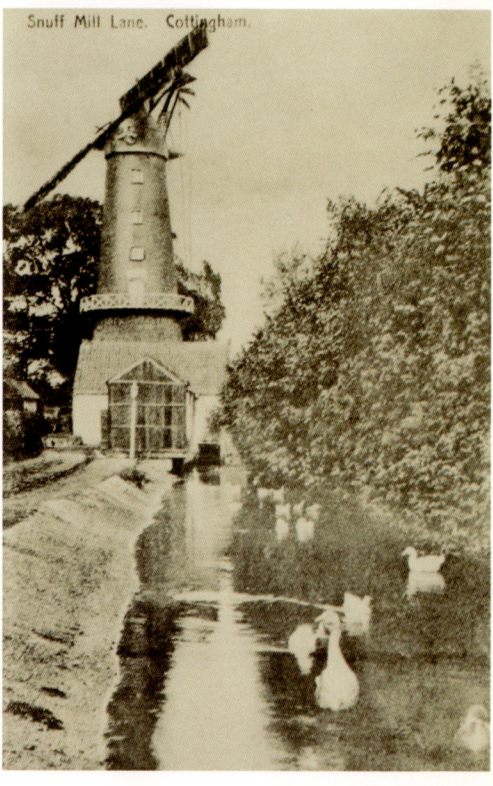

Dunnington

A windmill stood at Dunnington (EY) in 1295, owned by the Prebendary there. This no doubt was a wooden post mill. Following the mention of a windmill at this date, no other is recorded here until 1850, when a windmill stood near Four Lane Ends. The mill (top), however, was closed down by 1900, and derelict by the 1930s, when the photographer captured it on 28 June 1930 being used as an advertisement hoarding for an enterprising Tadcaster brewery. This was not an uncommon practice, seen also at Nafferton (EY) below. In 1822 William Parker was described as corn miller and coal and lime merchant. Standing four storeys high, at one period a painting of a windmill graced the outside wall to advertise the trade of the miller. This was later replaced by the present artwork advertising that the miller ground animal feed. Built alongside the Bridlington Road, steam power was added in 1840, and by 1892 it was described as the 'old windmill'.

28

East and West Cowick

Little is known about the mills of East Cowick (top), or indeed West Cowick. There is no record of any in ancient documents. However, a single windmill is shown on Jeffery's map of 1772 at East Cowick and another is marked at Turnbridge, between New-lands and West Cowick. In 1822 two corn millers are named at East Cowick, William Conder and John Walker, suggesting that two windmills stood at that date. In West Cowick a separate corn miller named William Nottingham is recorded at the same time. In 1932 Karl Wood painted the ruins of a mill at East Cowick. Right are the remains of the windmill at Thornton-le-Clay (NY); standing on a slight eminence beyond the mill house, it appears to have been derelict for many years; however, around 1913 it was known to have had both sails and a cap, though not working. Externally, the walls show signs of having been tarred to protect it from the elements as it stood in its isolated position overlooking the Vale of York.

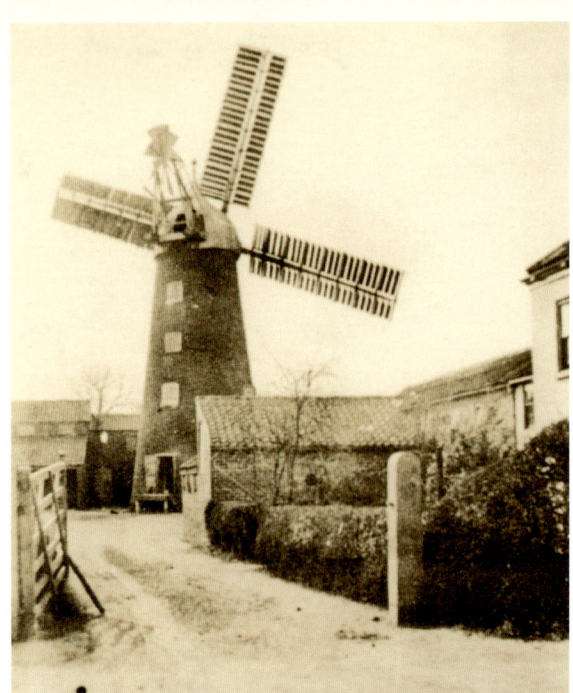

Ellerby

In 1830 the windmill at Ellerby (EY), sited near to the village railway station, was described as newly built and was owned by the Hull millwrights G. & W. Boyd. It is likely, therefore, that the mill was either erected by them as a speculation or, more likely, the miller for whom it was built was unable to pay the bill and so they were left with it on their hands. A mill was shown on Jeffrey's *Map of Yorkshire* in 1772. At what period this mill was rebuilt or simply disappeared is not known, therefore it is unclear whether this windmill of 1830 stands on a previous foundation. Reduced in height, by 1935 the tower mill was derelict and without sails. Later, before the Second World War, the mill has been converted into a private residence.

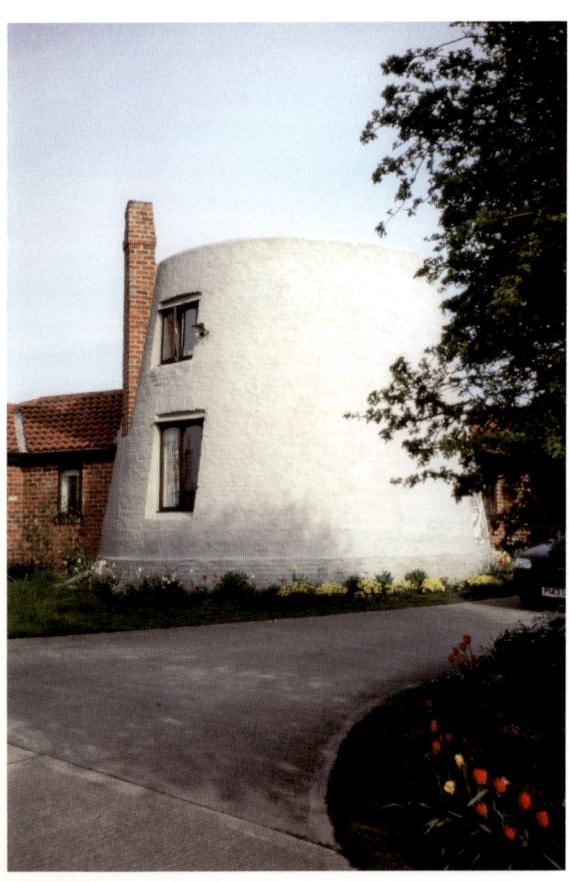

Muston

The windmill on the approach to Filey off the A166, standing on a rise near a school, is in fact that belonging to the adjoining Muston township, even though it is in Filey. It was erected in the decade 1820 to 1830 to replace an earlier post mill. It comprised a brick tower with four patent sails. A miller was last mentioned in 1913 and it probably fell out of use shortly after that date.

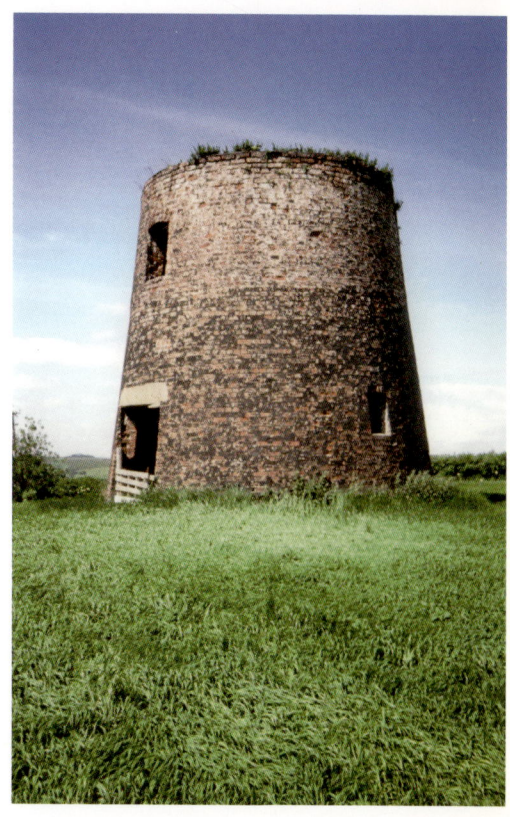

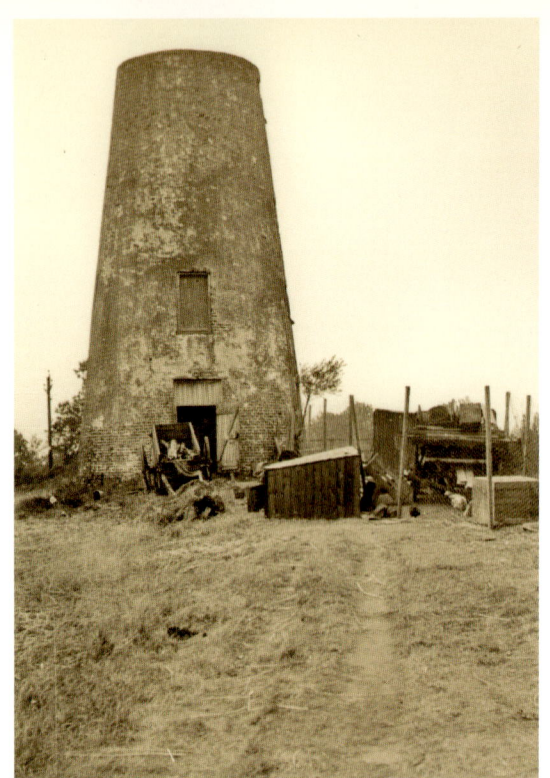

West Nab Mill

West Nab Mill at Fishlake is a standard type of tower windmill. A red brick tower with four storeys and three pairs of millstones, it was possibly built around 1830 and a late addition to the milling capacity for the village. Constructed of brick which was tarred, it had become disused by 1893. Today, it has been converted into a dwelling. Work undertaken to convert the windmill into a dwelling in 2003 revealed two millstones (see page 33) buried in the floor, one a French burr dating from about 1870, the other of Pennine millstone grit. Further archaeological work suggests that there was a previous wooden post mill on the site. The upper photograph dates from 22 August 1934, while that below was taken by the owner, Rob Austwick, in 2003 while the mill was being refurbished.

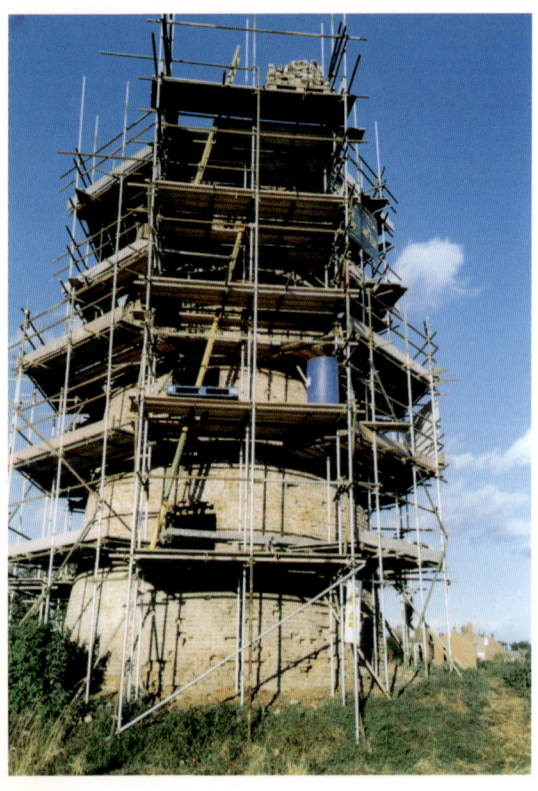

Fishlake

A brick tower mill of three storeys was built in Fishlake in East Field Road about 1770 and is probably the one shown on Jeffrey's map of 1772. Known as Millfield Mill, it had three pairs of millstones.
In 1889 a horizontal steam engine was installed, signalling the end of wind-power soon after. An older post mill in Wind Mill Road, a quarter of a mile further from the centre of Fishlake, was dismantled and its woodwork auctioned in 1839. This might have been used for a later post mill at Hay Green. The mill tower, together with adjoining buildings, has now been refurbished for use as a dwelling.

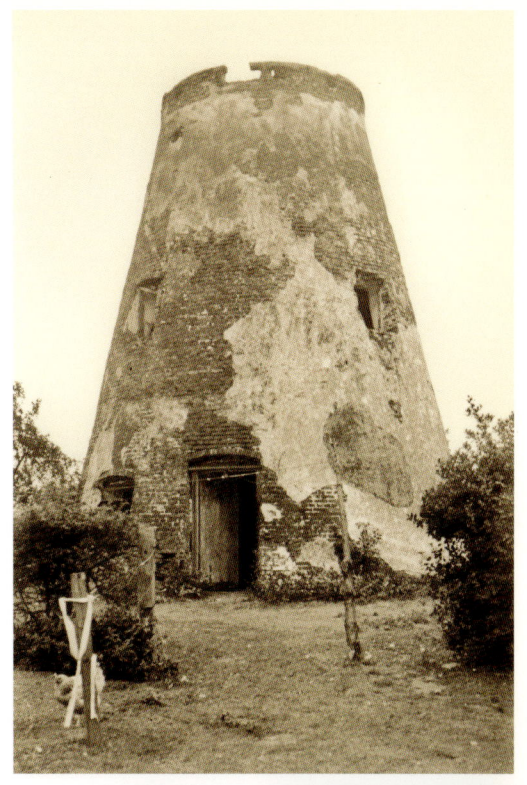

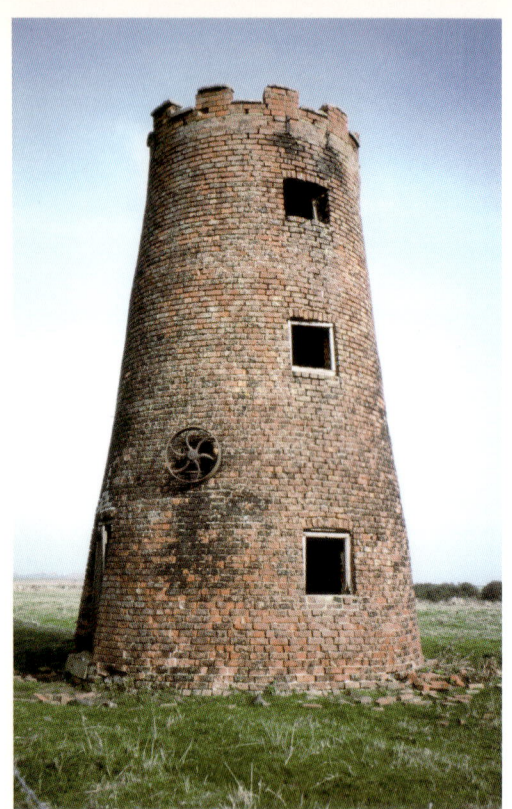

Garton

Garton, near Withernsea (EY), now derelict, stands isolated in a field on the outskirt of the village. The date of building is unclear, but thought to be about 1830. A miller is first mentioned in 1840. Small in stature, it measures approximately 35 feet to the top of the brickwork and inside at ground floor level it measures 15 feet 3 inches across. A single pair of French stones and a pair of Peak stones remain, each four feet in diameter. Internally, almost all the machinery survives intact with very little damage, and almost all of it is constructed of timber, some geared cogs included. One feature of interest is a bevel cog in operation with a second cog mounted on a horizontal shaft that passes through the wall of the tower to an external belt pulley to enable it to be powered by an external engine in times of calm. Below is the typical wooden gearing mechanism to turn the cap via an external fantail.

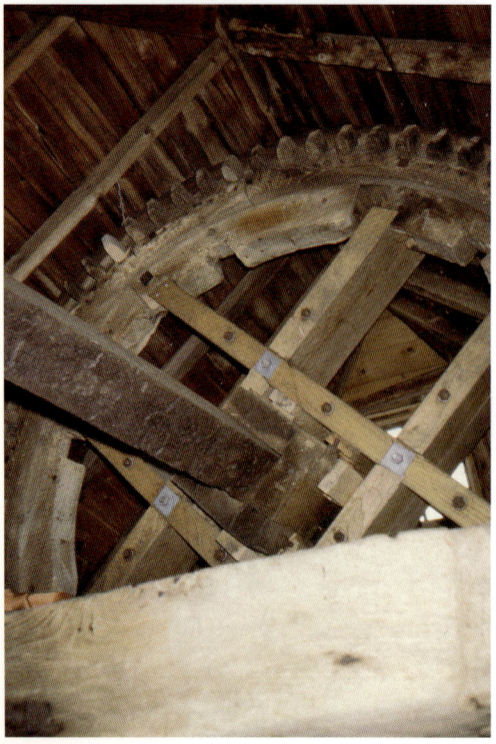

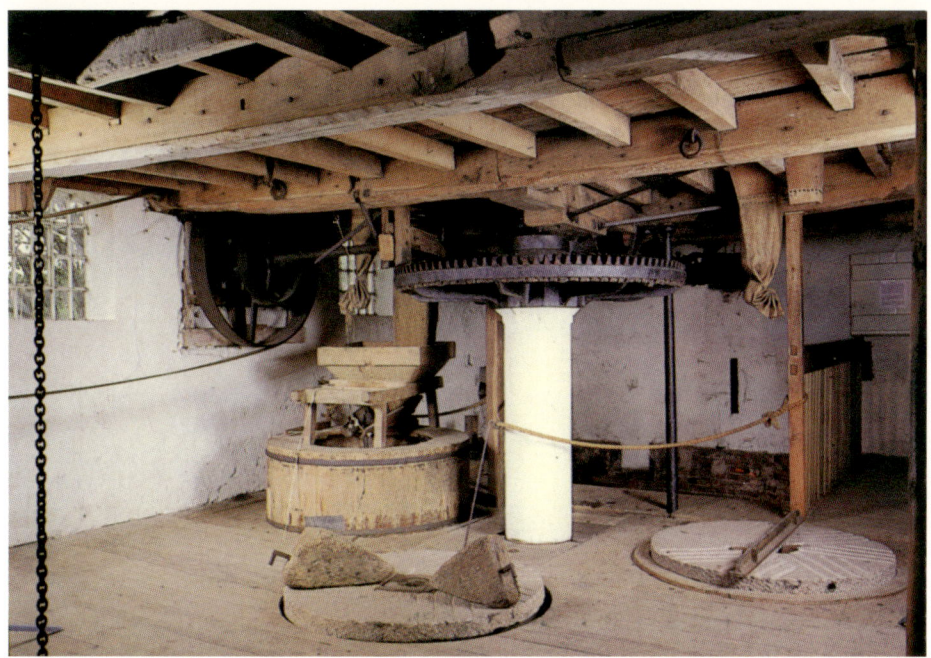

Goole

Goolefield Mill, Hook Road, Goole, now converted to a dwelling. A miller's life was not without danger; William Greenfield, miller of Goole, died in November 1840 after endeavouring to stop his windmill by taking hold of the sail; he was taken up a considerable height from the ground and thrown some distance from the mill. His back was much injured by the fall so that, after lingering in great pain, he expired, leaving a widow and several children.

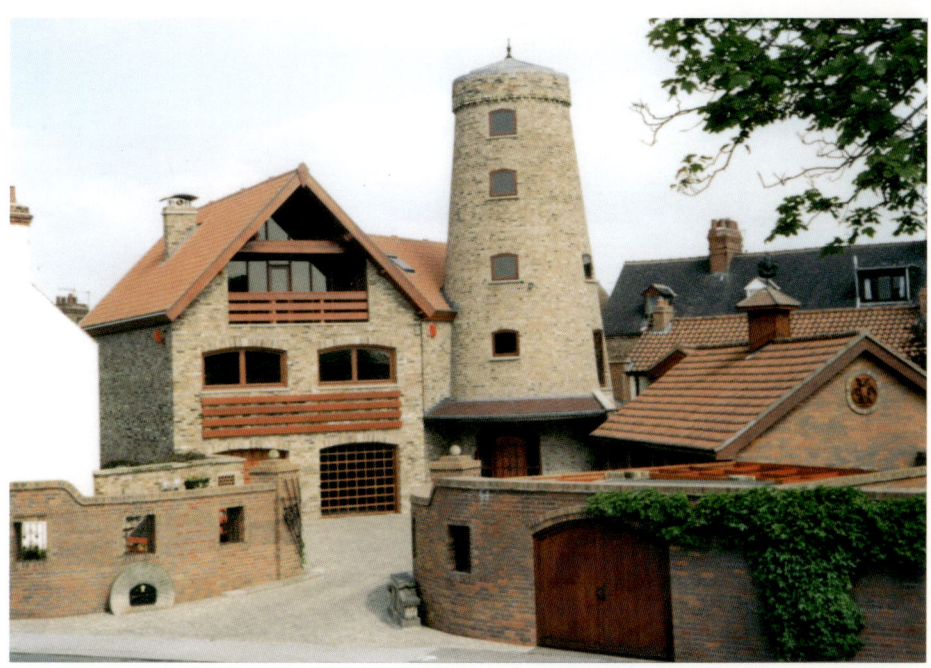

Hatfield Ling

Hatfield Ling's windmill was photographed on 22 August 1934 and is seen to be derelict, with no sails but retaining its ogee-shaped cap, albeit somewhat battered. It was first erected in the eighteenth century, but rebuilt nearly 100 years later. Four storeys in height and built of brick, the exterior was rendered and tarred.

Hatfield Woodhouse

Hatfield Woodhouse, Moss Croft Lane, photographed on 22 August 1934. Shown on Jeffrey's map of 1772, the ground floor to first storey height is built of Magnesian limestone, suggesting it is a rebuild of an earlier windmill. The mill stands in its entirety and has a brick dentil course, no doubt added when the crenellations were formed, at the time of its conversion to a residence known as Tower House.

Hemingbrough

Hemingbrough windmill, near Selby, top, could be the twin of Wrawby post mill, just over the Humber Bridge into Lincolnshire, seen below. The mill at Hemingbrough was in existence before the year 1770 and was a typical example of a Yorkshire post mill. It was later 'modernised' with the replacement of one pair of common sails with a pair of spring sails. At what date it ceased operations is not known, but the windmill was demolished in 1929. Common sails consist of a wooden frame over which sailcloth was tied onto the frame. Spring sails came later and consisted of wood shutters linked to a spring, the tension of which could be controlled manually in order to open and close the shutters according to the wind's strength. Post mills with cloth sails were once numerous in Yorkshire but have gone, and only at Wrawby can we see an example.

Hessle Whiting

Hessle Whiting Mill is a familiar sight to those who cross the Humber Bridge regularly. It was built by Norman & Smithson sometime between 1806 and 1812, for a group of quarry owners. Originally it was a horse mill, but it was later converted to wind power and continued (using roller sails) until 1925. The fantail shown in the picture was added sometime during the 1820s, as before that date the mill almost certainly had a tail pole when first erected. The process of abstracting whiting involved crushing lumps of chalk in water, using edge runner millstones, and allowing the resultant slurry to overflow along a series of settling tanks, where the chalk in suspension gradually settled out according to size. The coarse material was used in paint while the finest went into toothpaste and cosmetics. Work was undertaken to preserve the mill in the 1980s and all the internal machinery survives, although not working; it is possible to see how the mill operated from photographs and diagrams displayed inside.

Low Hawsker

Low Hawsker windmill was built around 1860 by George Burnett, who later had a mill in Whitby town. Hawsker mill was severely damaged by fire only a few years later in 1868, when the tar being coated onto the bricks caught alight. It was repaired and carried on working into the 1920s. The truncated tower survives and can be seen from the road and is currently being used as a storage shed.

Hinderwell

The last years of Hinderwell windmill. Built about 1848, it was converted to steam power soon after 1870, when the adjacent buildings and chimney were added. William Bishop was the miller there in 1879. The windmill itself stood seven storeys high and lay just behind the houses along High Street. It ceased operation before 1900, and the mill machinery was removed about 1915. The postcard is by H. C. Morley, of Staithes.

HORNSEA ACROSS THE MERE.

Hornsea
Built in 1820, Roy Gregory tells us the Hornsea Mill, below, is interesting as it is the only mill we can be certain was built by Messrs Todd & Campbell, iron founders of Hull. As one might expect, much of the machinery was made of cast iron. What is unexpected was the fact that the shutters in the patent sails were made of sheet iron. The mill has now been converted into a dwelling. Above, Hornsea from a distance, showing two, if not three, windmills.

The Windmill, Hornsea.

The Mill

The Mill Public House on Holderness Road, Hull, incorporates two listed buildings: the restored windmill tower with its distinctive ogee-shaped cap and sails (both modern replacements) and the separate Eyre's Cottages, which now form part of the bar area. It is these cottages and mill belonging to and operated by John Rank which was the birthplace of his grandson Joseph Rank (1854–1943), founder of the most famous flour milling company in the world.

Hutton Cranswick

Within a six-mile radius of Driffield are the remains of four windmills. The most complete of these is at Hutton Cranswick, where only the cap and sails have been removed. The brick tower is relatively slender and rises four storeys before the collar – two courses of brickwork – projects to mark the division between the accommodation and the octagonal neck on which the cap and sails would have been mounted. Internally, much of the machinery remains. It is not known when Hutton Cranswick windmill was built, but it was in existence by 1816. In that year the miller, Thomas Chambers was declared bankrupt. The documentation describes him as a farmer and miller. In 1822 the corn miller was Thomas Dawson. I was informed by the owner, a sprightly octogenarian, that the sails were dismantled sometime in the 1870s, but the machinery inside remains complete; he went on to say that when he retired from farming, as a hobby he was going to restore it!

Kellington

A Magnesian limestone tower with brick dressings still stands at Kellington, by the road from Knottingly, not far from the power station. Originally composed of four floors with a domed cap and fantail, an auxiliary drive was later fitted with into the tower at a low level so that it could be used during periods of calm. Wind power was used until the First World War, after which it was powered by a paraffin engine by Campbell of Halifax; however, all mill operations had ceased by 1927. During the Second World War it was used by the Home Guard as a look out post. Converted to a dwelling, it went into disuse but was employed in trials to grow mushrooms, but failed and became derelict. It has now been converted back into a private residence, albeit in a rather isolated and bleak landscape.

Keyingham

Two windmills survive at Keyingham (EY). Built in 1828, New Mill, left, had a lucky escape when struck by lightning on Good Friday 1897. The mill escaped serious damage but the lightning left its track, having peeled off all the paint on one side, from cap to base, while the chain used for hauling up sacks of grain was fused into an 'unrecognisable mass'. The mill was last operated around 1900. It has now been incorporated into a modern dwelling. Keyingham Old Mill, below, dates from around 1800. It was advertised for sale in December 1813 as a brick corn windmill with three pairs of stones, a new well-built house and about half an acre of land. It was for sale again in 1881 with 'a newly-created dwellinghouse.' It was wind-driven until 1910, after which it was powered by steam. The sails were removed in about 1911 and it ceased milling in 1940. A change of brickwork suggests that the top storey was added at another date.

Kilham

At Kilham (EY), west of Burton Agnes, a windmill was recorded in 1362, when it was said to be the manorial mill. This was last mentioned in 1694. On 1 July 1809, a 'newly erected and (in every respect) extremely convenient and well built' windmill south of the village, in Mill Back Side, was offered for sale. It was purchased by William Hutchinson, a tanner from Hunmanby who had recently resigned from that business. By 1823 the miller is shown in the directories as John Williams, until sometime between 1858 and 1872, when Robert Chandler took over. He remained in possession until 1913. The last miller is recorded in 1933. It appears therefore that the Union Mill was financed by subscription, but as soon as it was built, it was sold to a private owner. By 1889 steam had supplemented wind, and by 1937 oil-power had superseded steam. Notwithstanding, in the following year the mill was derelict when Karl Wood painted it. Today, the remains of the windmill form part of a substantial house.

Kirkbymoorside

At Kirkbymoorside (NY), almost invisible yet practically in the town centre, stands the remains of a windmill, today converted into a dwelling. Dating from 1839, a stone plaque records this fact and is further inscribed with the miller's name, 'G. Rivis', and the builders', 'W. & J. Spencley'. When first built it cost £1,000. Today, sporting a domed cap, it stands five storeys high. Internally, the ground floor measures 20 feet in diameter while the upper, fifth floor is 12 feet 5 inches in diameter. Constructed of red brick, originally it had a pitched roof as, unusually, this windmill never had any sails! When completed, it was found that any sails would encroach on the adjoining property's 'air space' and the neighbour was not prepared to give this up. As a consequence, it was only ever powered by a paraffin engine!

Langtoft

There was a mill at Langtoft (EY), situated high on the Wolds, as early as 1300. No further evidence of a mill is recorded until 1712. In 1865, a windmill described as 'the old post mill' was replaced by a brick structure. It was last recorded operating in 1925. Sometime in the early 1970s, the derelict stump, painted as such by Karl Wood, was converted into a residence, and the mill house into a restaurant.

Whin Moor Mill

Built of Magnesium limestone in the eighteenth century, the windmill at Seacroft on the outskirts of Leeds, on what was Whin Moor, was marked on a tithe map of 1834, when the owner was stated to be John Wilson, who leased it to James Pearson. A newspaper reported in 1767 that a storm had blown down a mill here. There were two pairs of millstones and room for a third. It was still in use in 1928, but not powered by wind. For many years during the 1930s it was known as Betty Barker's Mill, taking its name from the owner or tenant of the farm in which it formed a part; the farm was demolished in 1969. In some documents, however, it is recorded as Whin Moor Mill. Today, the windmill remains are incorporated into a hotel erected about 1971.

Sugar Well Hill Mill

Of the surviving windmills of Leeds, one can still be found at the junction of Scott Hall Road and Potternewton Lane, amid a housing estate and adjacent to a school. Built of locally quarried sandstone blocks and converted into a house, it went by the unusual name of Sugar Well Hill Mill or Sugar Well Mill, and was once the property of Jeremiah Dixon, who in 1775 advertised this well-situated and good-accustomed windmill to let, possibly not long after its completion. It was converted to a dwelling in the 1880s. Around 1898 the converted mill was lived in by Robert Bentley, who was over seventy years old. He grew tomatoes for the wholesale trade. In 1921 the property was purchased by Samuel Ingham, who renovated the building and carried on a business from the adjoining workshop. In 1949 Mr and Mrs Bedford occupied the property. The deep well-shaft in the yard cut through the solid rock which gave the mill its name was later filled in.

Lelley

A windmill is first mentioned at Lelley in 1280. This was probably the mill which was replaced on the same site between 1770 and 1793. However, the deeds show that there was a mill here as far back as 1712, but it is not clear exactly when the present structure was built. By 1873, steam power had been added to the mill, and the tall brick chimney of the engine house still remains on site. The boiler, too, survives, albeit in a dilapidated condition.

Little Smeaton

It is not known when Little Smeaton windmill was erected, but its fame lies in the fact that it was possibly the last medieval wooden post mill to survive in the county and was situated on the north bank of the river Went, six miles south-east of Pontefract. Free-standing, the wooden body of the mill was supported on a massive upright post that stood on a horizontal frame of two timbers crossed and jointed at right-angles. The upright post was further held in position by quarter bars of timber that ran between the horizontal cross-tree and the post. This arrangement allowed the entire body of the mill to be rotated into or out of the wind and so keep working in all types of conditions. While such an arrangement was considered the most common form and led to the name 'post mill', it has been known for the wooden support frame to be made up of Y-shaped or H-shape timbers. It was also not unusual to find mills supported by only a central post buried deep into the earth, a somewhat short-sighted practice. These photographs were taken in 1934 and 1961 respectively.

Post Mills

Normally the cross-tree was raised above the ground to allow air to circulate freely and keep the timber dry. However, a later practice was to bury the framework under an earth and stone mound to further support the often massive mill structure above. This was often done when finances were tight and it was not possible to rebuild the frame structure. Much later, a type of post mill evolved whereby the wooden mill body was erected on a raised stone or wood body, which then formed a dry storage area beneath. The life expectancy of most early post mills was roughly between forty and fifty years. This fast dilapidation is partially explained by such hazards as rotting timbers, the gradual tilting of the structure under constant wind pressure, storm damage and wood-boring insects. Today, not one single example of a post mill exists in the county, and it was a shame that the mill at Little Smeaton was not preserved. Although derelict for many years, it still retained the majority of its components.

Mappleton

Today an empty shell, Mappleton windmill near Hornsea (EY) still retains its original cap, though now dilapidated, mentioned by Roy Gregory in *East Yorkshire Windmills* as a fine example of the Lincolnshire Cap, a type universally fitted on tower mills in the East Riding. He also states that it was one of the earliest windmills to be converted into a dwelling. When I took the photograph in the 1990s, it showed no sign of its previous use. Mappleton mill was erected in 1798 of brick, which was later cement-rendered and tarred. Three storeys high, an internal staircase can be traced in the brickwork between the second and third floors. At what period it ceased to operate as a windmill is not known. Karl Wood painted it in June 1935 and shows it converted to a house. Internally, it measures 20 feet across and has two doors facing directly opposite each other, a not uncommon arrangement found in many mills. Sunk into the earth floor, a millstone remains. This measures 53 inches in diameter and is 6 inches thick.

Market Weighton

The first mention of corn mills at Market Weighton (EY) occurs in the nineteenth century, when there were at least four corn windmills. In 1822, William Baines' *Directory* lists five corn millers: William Cade, Market Place; John & Robert Dawson, Hungate; James Peart, St Helen's Square, William Vause, Cave Road, George Scott, Market Place. The only mill to survive was the one on Cave Road, a tower mill built of brick. This was demolished around 1970.

Monk Fryston

Although the mill at Monk Fryston (WY) was originally built towards the end of the eighteenth century, the mill was substantially rebuilt after storm damage in 1818 and can properly be regarded as a nineteenth-century mill. The ground floor was built of Magnesian limestone, but the three upper storeys were constructed of brick. By 1834 a steam mill was added, but eventually all the property was cleared away for housing in 1953. A windmill is shown to the south of Moor Monkton (NY) on Jeffery's map of 1772, standing along the edge of Hessey Moor. This may be the same windmill and site that was mentioned beyond the waters of the Ouse and Nidd in 1526. Photographed in 1942 (bottom), it is seen very much truncated and ruinous. It was also painted by Karl Wood in 1933, who depicted it without sails or cap and somewhat taller in height.

Norton

By 1932, the windmill at Norton, north of Doncaster, off the Selby road, was derelict. At that time, Karl Wood painted it. The achievements of this man, born in Nottingham in 1888 and who later moved to Gainsborough, provides us with details of many windmills in the early decades of the twentieth century. Karl Wood painted 1,394 windmill pictures in total and no less than 139 in Yorkshire. Today, the entire collection now rests in the hands of the Lincolnshire Museums Service. Standing six storeys in height, it is built of brick, rendered and finished with an ogee-style cap. Its original date of foundation is unknown, but it undoubtedly dates from the nineteenth century, possibly a rebuilding on an earlier site. The rendering of a windmill with either tar or cement was necessary in numerous cases to provide a weather-proof exterior, as the majority of windmills were erected in open, exposed and elevated positions. As a consequence they took the full brunt of inclement weather conditions.

Osgodby

Above, at Osgodby (EY), a windmill stood near Cliffe Road, south-east of the village. As there is no mention of an earlier mill in manorial records, nor is a windmill shown on Jeffrey's map of 1772, then it is possible that the history of the windmill here only began at the start of the nineteenth century. Baines' *Directory of Yorkshire* of 1822 names the corn miller as Michael Brown. Below is the now demolished windmill which stood on Holderness Road, Hull.

Patrington

At one period three windmills stood at Patrington, East and West Mill and Goodrick's Mill (above). It is recorded that the son of the last miller, James Goodrick, claimed in 1936 that the mill was built in 1845. However, prior to the present mill, there was a post mill and an advertisement in the *Hull Advertiser*, dated 20 May 1809, offered for sale a '... good substantial post mill' which after sale must be '... immediately taken away from the premises'. James Goodrick only acquired the premises in the 1890s.

Pontefract

Pontefract (WY), being an ancient town with a castle, undoubtedly had windmills at an early date, but no record survives of these. However, in the nineteenth century three windmills existed, two of which were familiar landmarks for many years – St Thomas Mill and Dandy Mill (see pages 61, 62 and 63). This third windmill, photographed in 1934 as a ruined shell but still with its machinery inside, is unidentified.

61

Dandy Mill

Intriguingly, Dandy Mill at Pontefract may have had an earlier name, as inscribed over the first-floor window facing Water Lane are the words 'Boreas Union Mill 1819' in two different lettering styles. Boreas is the classical name for the north wind. Authorities are puzzled by this inscription and its siting on the building, and records are scant and of no assistance. Dandy Mill was erected in about 1803 by a Dutchman who later erected Darrington windmill. Dandy Mill stood south of the railway line, near to Pontefract Castle and the old church of All Saints. Tall and slim, it was built of brick and later tarred. Somewhat unique in design, the base splayed outwards noticeably from about 10 feet above ground level. The mill had three pairs of millstones on the third floor, rather than the more usual first or second floor. Although wind powered, it can be seen that arrangements were made for the millstones to be turned by an external engine. Indeed, after 1922 it was entirely powered by a gas engine until 1941.

St Thomas's Mill

According to Roy Gregory in his book *Windmills of Yorkshire* (2010), St Thomas's Mill, Pontefract stood at the top of Mill Lane, at the corner of Orchard Head Lane, from the earliest years of the nineteenth century. It was probably slightly larger than Etton Mill, having four pairs of millstones (compared with only two at Etton), and all four sails were roller reefing. The upper photograph, taken in the 1920s, shows its stone construction, with patchy mortar added. It was rebuilt as a house (below) with a prominent chimney and additional rooms. Estate housing encroached by 1963 and the tower was demolished before 1969. It was sometimes known as Nevison's Mill, in remembrance of an infamous highwayman of this area. Luke Ward was miller here from 1893 to 1908, having previously been at nearby Dandy Mill from 1877 to 1889.

Ravenscar

Ravenscar is situated on the coast between Whitby and Scarborough. The four-storey windmill of stone has the date 1858 carved into its plinth. When newly erected it was known as Peak Mill and was associated with an adjacent inn, both leased by the owner, Mr Hammond of nearby Raven Hall, to the miller and his wife. At what date it ceased operations is not known, nor indeed when the two properties changed to become Peak Farm.

Riccall

In 1295 a windmill stood at Riccall (NY). Later, a second windmill was mentioned as belonging to the Bishop of Durham. By 1803 this had disappeared, and its site was marked as the Old Mill Hill in West Field. During the 1840s, again, there were two windmills at Riccall, one in West Field and another in East Field. West Field Mill had steam power by 1889, but later reverted back to wind power and survived until about 1910. East Field Mill was not mentioned again. It was while engaged in work on the mill at Riccall during the nineteenth century that George Reed, millwright, of Howden, was fatally injured when he fell from the top of the windmill tower. The original mill in West Field was replaced in 1811. This brick tower windmill had four sails and three pairs of grind-stones. It was converted to steam power, but fell into disrepair in 1911, when it was refurbished as a private residence by Mr and Mrs Franklin. This was later sold to Manolita Brage, who turned the mill into a charming restaurant.

65

Rotherham

In Rotherham, two windmills stood in 1827 at Doncaster Gate, and were shown complete at that date in Thompson's *Hallamshire Scrapbook*. A photograph taken about fifty years later shows them derelict, above. Built of stone, the mills stood five storeys high and were practically cylindrical. One had a curious circular room running around the base of the tower, possibly a storage area. On a map dated 1890, one of these two mills, presumably the more ruined, is described as the old windmill. Photograph: Rotherham Central Library, Archives & Local Studies Section.

Dalton Brook Mill

Another windmill that survived into the nineteenth century at Rotherham was that known as Dalton Brook Mill. This mill, above, was photographed around the end of that century, but it was not recorded on the first edition Ordnance Survey Map of 1890. The mill house, however, survived and later became an inn. Today it continues to survive, and has been converted into housing, like the mill below at Reedness. Photograph: Rotherham Central Library, Archives & Local Studies Section.

Scarborough

In Scarborough, just off Victoria Road, up Mill Street, stands a restored brick windmill, now part of a hotel. It was erected around 1785 by Thomas Robinson. In 1796 it was owned by a Dr Belcombe, who acquired it from a Jack Binns. Originally called Common Mill, it was erected on land belonging to Scarborough Corporation and was operated on leasehold. Moses Harrison ran the mill in partnership with his brother Francis as a corn and seed merchant business. It is thought Moses bought the windmill about 1850 from a Mr Harland, who later became connected with the Belfast shipbuilders, Harland & Wolff. After coming into the possession of his son, Albert, it continued in use until the autumn of 1927. First powered by six sails, some or all were blown down in a gale in 1880, falling on a cowshed and killing a cow. Only four sails were used afterwards. These were removed in 1898. From this time, the mill was fitted up with a 12hp gas-turbine engine.

Seaton Ross

Two mills stood at Seaton Ross, Fishers Mill (top), and Preston's Mill (bottom). This latter was one of the last two windmills in the East Riding to operate by wind power and was dismantled in 1951. In January 1839, the *Hull Advertiser* carried a story about the partial destruction of a mill that may have been Preston's Mill. 'The beautiful corn mill (which is upwards of seven storeys high) belonging to Mr R Cook, of Seaton Ross, had the top completely carried off, together with part of the wall, which, before it fell, presented a grand but awful appearance; from the top to about the fifth storey the wall on each side opened and shut twelve or fourteen inches, as the sails were going round the gearing. The stones were laid on their faces to prevent its progress, but which in reality aggravated its previous effects. The neighbours and tenant were in the act of carrying water to the top to prevent the mill firing, when it came down altogether into an adjoining garden, the top etc being smashed to pieces.'

Mill Dam

In 1760, two watermills on the Mill Dam stream at Selby were demolished and replaced by one combined building – a windmill and watermill. A print of 1800 shows just the windmill with a boat-shaped cap and four common sails and a horizontal fantail. The photograph below of 1884 shows the tower without sails; it was demolished two years later. Nothing is known about the windmill above, photographed on 8 August 1942, but it may be a replacement for that of 1800.

Shelf

In the Bradford district the last corn windmill to survive was that at Shelf, on the Halifax Road. This dilapidated and crumbling structure remained until the early 1960s. It was built of locally quarried stone and erected during the nineteenth century, replacing an earlier mill. To the end it retained most of its original machinery and was photographed in 1942, missing only its cap and sails; Karl Wood painted it in 1937, also showing it derelict.

Barraclough Mill

This mill is thought to have been originally built in 1789 and run by members of the Barraclough family from 1852. It continued to be wind powered until 1904 and had a domed cap with a handsome finial, four common sails and a tailpole. The tailpole had a cartwheel at its base and a winch with a chain which could be attached to a series of posts set around the mill to make it easier for the miller to turn the mill cap about. It was demolished in 1963, and from the photograph below it is possible to see the great thickness of the walls. It had had three pairs of millstones, two pairs of which were over five feet in diameter. There was evidence to show that the brake wheel was originally turned by a wooden shaft, later replaced by iron. Unusually, the means of adjusting the gap between the millstones was operated by a series of levers on a fulcrum instead of the more common governors and suggests a Dutch influence in the design.

Sherburn-in-Elmet

The windmill remains at Sherburn-in-Elmet (WY) were last mentioned in 1959. They were described as a site only, suggesting that the ruins photographed in 1934, below, had disappeared. The stump shows that it was constructed of brick and appears to have a semi-circular arch below the windmill to provide dry storage. This indicates that it cannot have been the mill above, also at Sherburn, so there may have been two mills here. The basement of this mill was a tank into which rainwater was conducted.

Skidby

Standing on a ridge of the Wolds, the black tower and white sails of Skidby windmill are easily spotted when travelling along the road toward the Humber Bridge from Beverley. Built in 1821 by the Garton family of Beverley, it replaced an earlier mill that had stood here since the Middle Ages. In 1388, this post mill was leased from the lord of the manor for £1 6s 8d per annum. In 1854 the windmill was bought by Joseph Thompson, and it remained with his family until taken over by the Weston Group. In the twentieth century the mill was powered by electricity set up in 1954, but retained its sails. Seventy-two feet tall to the curb, the Lincolnshire cap measures another seventeen feet. Each of the four sails is 9 feet wide and has a sweep of 28 feet. Damaged by lightning in 1946, it was the last windmill to work in the county, and as such brought a response by the Society for the Protection of Ancient Buildings for its preservation.

Beverley Rural District Council
In 1968, the Weston Group donated the mill complex with machinery to Beverley Rural District Council. The council established a small museum of relics connected with grinding corn while preserving it as a working mill. The windmill boasts three pairs of stones – one French pair for flour, and two pairs of Peak stones for grinding feed. It is the only surviving wind-powered mill in Yorkshire: telephone 01482 848405 for opening times.

75

Skidby Mill

The original builders of the mill were Norman & Smithson; however, the alterations to the internal layout when the tower was raised were carried out by the millwright George Reed, of Howden. The interior of Skidby Mill, showing in the upper photograph the three pairs of stones used for grinding both corn and animal feed: below, the governor mechanism that controls the flow of grain into the grain hoppers.

South Duffield

Drax Priory had a windmill at South Duffield (EY) in 1311. A windmill was shown on Jeffery's map of 1772. A mill operated throughout the nineteenth century. In 1935, when photographed above, just after closure, the sails had become broken and a pair lost. Below, in the yard of Windmill Farm, near Eden Camp War Museum at Old Malton, stand the remains of a three-storey red-brick windmill, which serves as a farm store.

77

South Skirlaugh

One of the last post mills to survive in Yorkshire stood at South Skirlaugh. It was said that the mill had been there since 1250; although this is unlikely, there is evidence to suggest a fairly early date for its construction – probably the seventeenth century. In 1822 the miller was Robert Waldby. Of interest here is the fact that unlike most wooden post mills that contained two pairs of millstones, one in the breast and one in the tail, Skirlaugh contained three pairs of stones in 1852. It was demolished in 1944. Another feature of interest is the enclosed trestle, which is not unlike that of the York windmill below, standing on Burton Stone Lane. In the fourteenth century there stood at its northern end a windmill, which was described in 1374 as the mill of John de Roucliffe, and bore the name of Lady Mill. The historian Davies indicates that a windmill stood here in his day and had the name of Burton Mill, and was one of two windmills hereabouts demolished around 1878.

Stutton

Overlooking the A64 York to Leeds road, near Tadcaster, stand the remains of Stutton windmill. Built of Magnesian limestone quarried nearby, where the quarry pit can still be seen on the opposite side of the road, the tower, although four storeys high, appears short and squat, and the walls have a pronounced taper. These are constructed in this way to give added strength in its elevated position. Internally, the mill measures approximately 22 feet in diameter and has walls 2 feet thick. On the ground floor is a fireplace, with the flue built within the walling. Possibly erected in the eighteenth century, inside the shell are remains of two millstones. Both the upper and lower millstones are marked with a cross. As the mill originally belonged to a noted Catholic family, it is probable that the devout owners had the stones blessed by a priest. Another interesting feature of the mill at Stutton is that in shape, size and material, it is an identical twin to the demolished windmill at Laughton-en-le-Morthen, near Rotherham, which was known as Carr Mill.

Thorne

Six windmills stood in Thorne (SY) in 1853. The earliest reference to a windmill occurs in the court rolls of 1275, when William Scutard was accused in his absence of falsely setting the stones 'in order to steal the flour of the customary tenants'. One stood at the top of Brooke Street, or Crust's Mill Road as it was known and was called Bell-wood's Mill. On the North Eastern Road, at a crossroad, stood Casson's Mill. To the right was Hemingway's Mill. Oldfields Mill stood in South-field Road. Far Post Mill lay to the south of Thorne North Railway Station. The only windmill to survive was this brick tower mill on North Eastern Road known as Oates' Mill, after the last family to work it. The sails broke off about 1880, after which time the windmill was powered by a steam engine. By 1935 it was converted into a residence. The windmill below is that at Sewerby near Bridlington. A miller was last recorded in 1937 and the mill was derelict by 1969. Today, it is the office of a caravan park.

Tollerton

The windmill at Tollerton (NY) possibly dates from the eighteenth century, but is not marked on Jeffery's map of 1772. In 1822 the corn millers were two brothers, George and John Suggitt; consequently, if the mill was not standing at the time of Jeffery, then its date of erection could have been in the last quarter of that century, or at the very beginning of the nineteenth century. Little else is recorded of its history. It went out of use before the Second World War, and although efforts were made to preserve it, these failed. It is said that while it stood empty, a sail blew off in a gale. If this occurred, then it was repaired, as in August 1942, when the windmill was being dismantled and this remarkable series of photographs was taken, it still had four sails. At this date the wands were removed and the machinery inside was taken away. The windmill stood as a derelict tower in 1959, and is today converted into a house, though reduced in height.

Hooper's Roller Sails
Built in 1815, the windmill was fitted with Hooper's Roller Sails, which employed the use of roller blinds instead of shutters, but these still had to be manually operated. Closed in 1936, the conversion to a house has perhaps not been as sympathetic as it could have been; with its panoramic 360-degree-view upper storey, it is more like a lighthouse in an agricultural landscape.

Ugthorpe

The present windmill at Ugthorpe (NY) is visible from the A171 which runs between Whitby and Guisborough; it was erected in 1796 on the site of an earlier structure. In 1860, the mill was offered for sale and an advertisement appeared in the *Whitby Gazette*. 'MR JOHN P LINTON WILL OFFER BY AUCTION; on Friday, the 10th August, at Three o'clock in the Afternoon, at the house of Mr David Smallwood, the *Black Bull Inn*, in Ugthorpe . . . subject to such conditions as will be then and there produced, all the capital Freehold Corn WIND MILL, Dwellinghouse, and garden, with the small garth near the same, called 'Hunt House Garth' containing about One Acre situated at Ugthorpe aforesaid, now occupied by Messrs John and Robert Wilson, the owners. The Mill contains Three Pairs of Stones – one French and the other Grey – a Cylinder, and all other conveniences for carrying on to the greatest advantage the Business of a prosperous Agricultural to the rising population of the district.'

Ulleskelf

It is thought the windmill at Ulleskelf was built in 1770 and had common sails, mounted on a cast-iron cross, and was winded with a Dutch-style tailpole, the tailpole and sails being operated from the ground. The bottom stages were of stone with brick above, then cement-rendered. The mill operated three pairs of millstones. It ceased operations in 1907, and twenty years later it was converted to a private residence.

Walkington

Walkington windmill, photographed on 27 July 1935, showing it disused. It is thought that this windmill was erected around 1850. Similar to Lelley (page 51), it was tall, six storeys high; the door to access the stage at second floor level can be seen. Little is known of its history, and Mr Gregory suggests that the steam engine was added in the 1880s. The mill was finally taken down in 1971.

Wentworth

The earliest reference to a windmill at Wentworth, near Rotherham, occurs in 1590, when a series of manorial by-laws was drawn up, one of which stated 'every person within the lordship do grind his corn at the lords windmill'; failure to comply meant a fine of 3s 4d. A windmill was repaired between 1769 and 1770, when the Estate Account Books mention on 13 November 1769, 'Christopher Evers in full for the repair of a windmill, etc upon quitting the same, £26 5s 0d.' A year later, on 14 October 1770, is written, 'John Marshall then and before for work done and materials found in and about repairing Wentworth windmill in full, £63 0s 6d.' In 1745, Lord Malton built 'a new wind miln' at Wentworth; this was probably the mill now known as The Round-house, in Clayfields Lane, which has a stone base and brick walls. In 1793 it was replaced as a working mill by a windmill at Barrow (see page 10), half a mile away, but this became redundant itself in 1834. Photograph: Rotherham central Library, Archives & local Studies.

Wetwang

The windmill at Wetwang (EY), top, situated in the north-west corner of the village, along Northfield Road, remained a post mill throughout the eighteenth century. This was a period when most millers thought them outdated and were replacing them with brick tower mills. Wetwang mill was different to many other post mills in another respect, being fitted with an unusual feature not found on many post mills. In most cases, the striking rod mechanism on the sails of the East Riding post mills employed to open and close the shutters was controlled by a rack and pinion arrangement. Here, however, a rocking lever was fitted, and the windmill provided with a rear platform to give access to the striking chain. This arrangement is more commonly found on the later tower mills of the nineteenth century, which shows that while the miller was perhaps old-fashioned in some ways, he was nevertheless sufficiently familiar with current trends in windmill design to install the latest type of gearing to his mill when available. Bottom, the ruins of Waxholme windmill.

Union Mill

Union Mill, Whitby, unusually, had five sails and stood at the junction between Chubb Hill, Stakesby Road and Upgang Lane, on the site of Harrison's garage, which in 2010 was demolished, and by March 2011 had been replaced by the apartment block known as Union Mill. The Union Mill Society was founded in 1800 and by 1817 had some 900 members, who benefited by obtaining flour at a reduced rate.

Union Mill Society

Above is a member's ticket, which had to be produced each year when collecting flour. It is marked with tiny squares, stamp marks, and this led to the saying 'going through the mill', as a member would have his ticket stamped on entrance and then go through the mill to receive his measure of flour at the other side. The Union Society was wound up in 1888. The mill was later used as a drill hall by the Territorial Army.

Hull Subscription Mill

Union Mills and Societies could be found in many towns, established to combat the rising costs of flour and bread. Above, like Whitby, is a member's pass for the Hull Subscription Mill Society. Their mill stood in Danson Lane, Hull, below. It had four patent sails and was one of the tallest in the county. A somewhat unlucky building, during its construction a number of accidents occurred, including a death. Photograph of pass: Local History Unit, Hull College.

Stakesby

The Whitby windmill known as Stakesby Mill was erected in 1778. It had common sails and an unusual cap for Yorkshire, which shows some individuality. The cap was turned into the wind using a winding wheel. At a later stage, the mill at Stakesby was modified by the addition of patent sails and a more usual fantail arrangement. It continued to operate until 1877; it was later demolished, and today the site is being covered by an apartment block.

Wilberfoss

At Wilberfoss (EY), a windmill was included in the grant of the former Priory property there to George Gale in 1533. A windmill was mentioned again in 1624 and may have been the same as that recorded in 1669. A second mill stood at Wilberfoss from 1823, and a miller was last recorded in operation in 1933, the same year that Karl Wood made a painting of a windmill which shows it already disused and with only partial sails. This windmill was sited on a moraine north-east of Wilberfoss. This mill fell during a storm on Plow Monday in the year 1838 and was replaced in brick. The name Mill Field on early maps suggests that there was at least one earlier windmill in the parish and in 1755 an oat-meal mill stood near the beck at Wilberfoss, close to the stone bridge. Below, the remains of the windmill at Yokefleet. This early brick tower mill was in existence in 1780. Milling ceased around 1860, and has since then been used for various agricultural purposes.

Yapham Mill

Yapham Mill near Pocklington (EY) was built in 1805, by William Daniel, millwright, of Pocklington. Photographed in 1935, the cap and sails have gone, but the curb remains. The ground floor and the first floor are known to still retain some of the original machinery. Built of brick, the mill is waisted, and is not unlike Holgate windmill in York. Such a design is typical of Lincolnshire windmills. Roy Gregory in *East Yorkshire Windmills* records that the 'stone floor', set at first floor level, at some date contained three pairs of stones: two pairs of French Burrs 4 feet in diameter and one pair of Peak stones measuring 4 feet 2 inches in diameter. There is no maker's name around the eye of one of the French stones and the runner stone has disappeared from the other pair. However, a piece of broken casting, possibly from the missing runner stone, suggests that they were from one of the Hull firms of French stone makers. Originally, it is thought that when first erected, the mill had only two pairs of stones.

Mill Postcards

Upper photograph: a fine view of the old windmill at Greatham, near Darlington. This Brittain & Wright postcard bears the date of 1909, and the sender, who was on holiday in Greatham, tells his friend that the mill was still used at that time to grind oats and other cereals for feeding stuffs. Below, another excellent postcard view of the Mount Pleasant Windmill, Darlington, which stood to the east of Norton Road, near the Windmill Terrace. It was erected before 1785, and was seven stories in height. The windmill, almost complete, stood until at least 1920, after which date it was demolished.

Holgate

Of all the windmills that have ever stood in York, the only one to survive is that at Holgate. At one time known as Severus Mill, its site can be traced back to 1366, when a post mill first stood here. The first miller of whom we have any record connected with Holgate Mill was named William Plewman, who in 1573 was fined 13s 4d by the manor court for 'not bringing the Toll Dishe according to custom', a necessary duty attendant with the responsibility of medieval Soke Law. In 1792, it is recorded that George Ward had 'latterly erected a brick windmill and adjoining dwelling house' replacing the earlier wooden post mill; it is this brick windmill that stands today. Holgate Mill, as it became known, remained in production until about 1930, when it closed due to its unsafe condition. Presently the mill remains almost complete, though hemmed in by housing. Yet with such affection is the mill held that the Holgate Windmill Preservation Society was formed in 2001 to rescue and restore this building. Details via: www.holgatewindmill.org.

Dressing a Millstone

Top left: Mr A. Robinson, former miller of Rievaulx, having rubbed of the millstone with a hard stone, is proving it with a staff smeared with red rudd. *Top right*: The furrows (or grooves), which must be the correct depth, are marked out using a feather dipped in rudd and water and measured out by two lathes known as the furrow spline and the land spline. *Middle left*: Dressing the furrow with a mill bill (or pick). The furrow has a straight and a sloping side. *Middle right*: Dressing a furrow using a mill bit with a chisel. *Bottom*: Finishing the top stone by giving it 'swallow', that is creating a saucer shape so that the corn flows in more easily.